The 1940s

BRITAIN IN PICTURES

AMMONITE
PRESS

PRESS
ASSOCIATION
Images

941·084

First Published 2012 by
Ammonite Press
an imprint of AE Publications Ltd,
166 High Street, Lewes, East Sussex, BN7 1XU

This title has been created using material first published in
Britain in Pictures: The 1940s (2008).

Text © AE Publications Ltd, 2012
Images © Press Association Images, 2012
Copyright © in the work AE Publications Ltd, 2012

ISBN 978-1-90770-864-0

British Cataloguing in Publication Data. A catalogue
record of this book is available from the British Library.

Editor: Ian Penberthy
Series Editor: Richard Wiles
Picture research: Press Association Images
Design: Gravemaker + Scott

Colour reproduction by GMC Reprographics
Printed and bound in China by C&C Offset Printing Co. Ltd

Page 2: Charterhouse
Street, Holborn, looking
towards Smithfield, London,
during the Blitz.
10th May, 1941

Page 5: Holidaymakers
enjoy the sun on
Bournemouth beach.
1st July, 1946

Page 6: A family at home
watching television.
15th December, 1949

The 1940s

BRITAIN IN PICTURES

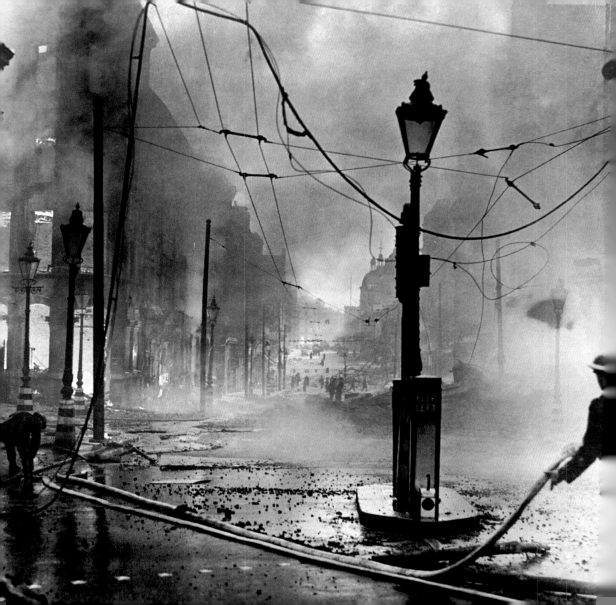

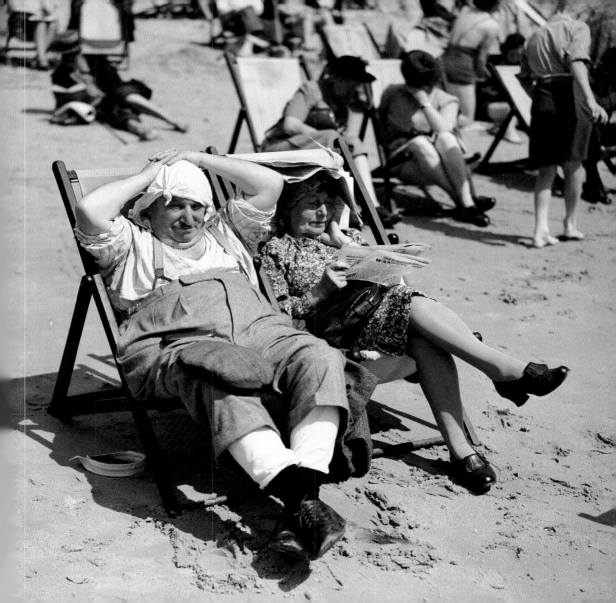

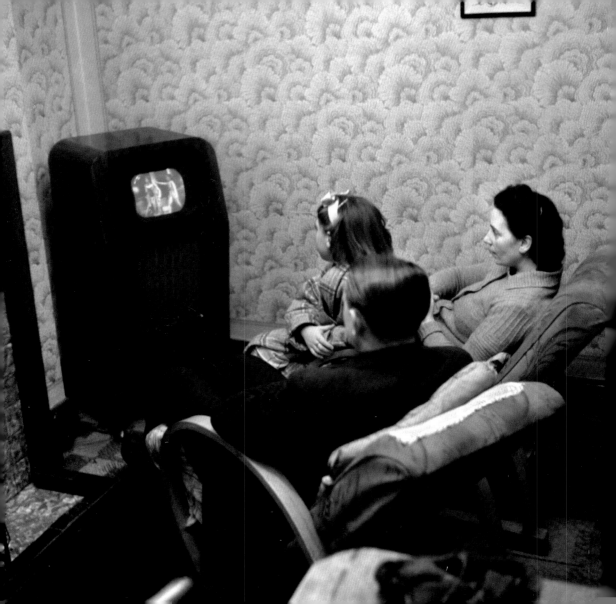

Introduction

The archives of PA Photos yield a unique insight into Britain's recent past. Thanks to the science of photography we can view the 20th Century more accurately than any that came before, but it is thanks to news photography, and in particular the great news agency that is The Press Association, that we are able now to witness the events that made up life in Britain, not so long ago.

It is easy, looking back, to imagine a past neatly partitioned into clearly defined periods and dominated by landmarks: wars, political upheaval and economic trends. But the archive tells a different story: alongside the major events that constitute formal history are found the smaller things that had equal – if not greater – significance for ordinary people at the time. And while the photographers were working for that moment's news rather than posterity, the camera is an undiscriminating eye that records everything in its view: to modern eyes it is often the backgrounds of these pictures, not their intended subjects, that provide the greatest fascination. Likewise it is revealed that Britain does not pass neatly from one period to another.

The years between 1st January, 1940 and 31st December, 1949 saw the country taken to the brink of disaster, and begin its initially shaky journey to recovery. Unlike the First World War, for Britain the Second was fought as much in its cities, towns and villages as it was in Europe and elsewhere – in its skies too, as the pivotal stage of the war known as the Battle of Britain raged in the summer of 1940 and the air war brought the front line to the cities. In no other British war have ordinary people participated so actively as their homes were destroyed, their children evacuated, their lives overturned.

While the second half of the decade is often characterised as an aftermath of that conflict, we see, in the pictures of the time, a looking-forward, not back. The marriage of the young Princess Elizabeth and the birth of her first child Charles meant that by the end of 1949 Britain had a new Royal family in waiting. More ordinary women were also stepping forward: having moved into traditional male roles by wartime necessity, it seemed unlikely that they would entirely settle back into meek domesticity.

Something else had changed. A flickering blue light in the corners of some parlours heralded a new age for news, entertainment and society. Its repercussions for families – Royal and common alike – were to be profound.

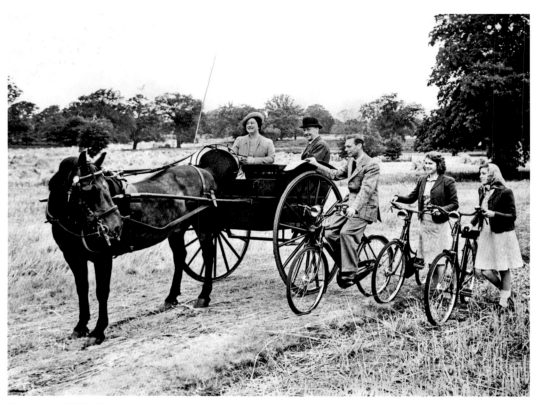

King George VI (third L),
the Queen (L) and
Princesses Elizabeth
(second L) and Margaret (R)
take a ride in the countryside
in wartime Britain.
1940

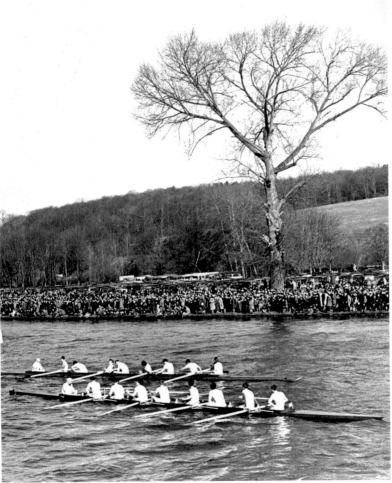

Cambridge University defeated Oxford University in the 1940 Boat Race. Due to the war this was held at Henley, for the first time since the inaugural Boat Race in 1829.

1940

A motorcyclist of the 1st Canadian Reconnaissance Squadron enjoys a cup of tea during an interlude in the day's work. Behind him can be seen a Lewis machine gun of First World War vintage.
1940

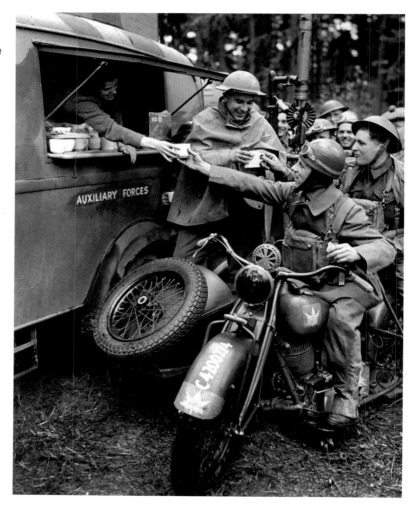

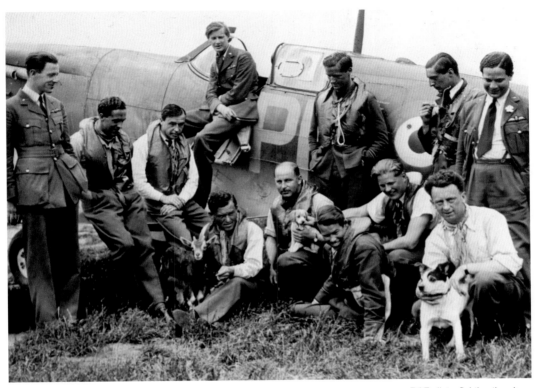

RAF pilots, fighting the air
war over occupied France,
relax with their mascots on
and around a Spitfire.
1940

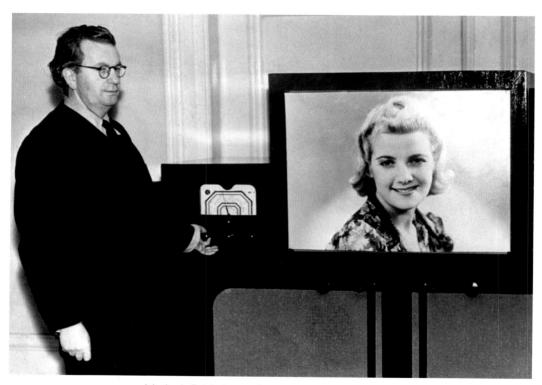

John Logie Baird, pioneer of
television, demonstrates his
latest invention – for showing
television pictures in full,
natural colours.
1940

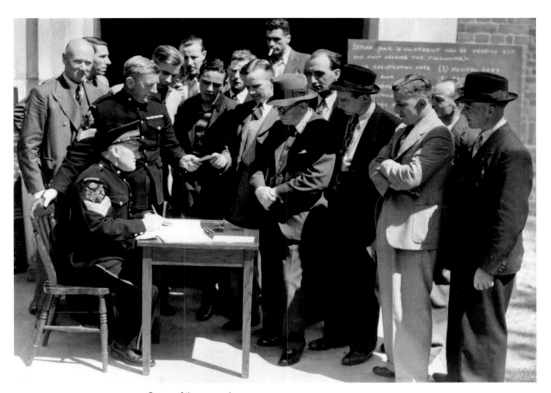

Some of the men who
answered the British
Army's call for volunteers in
discussion with Recruiting
Sergeants at a West London
recruiting office.
1940

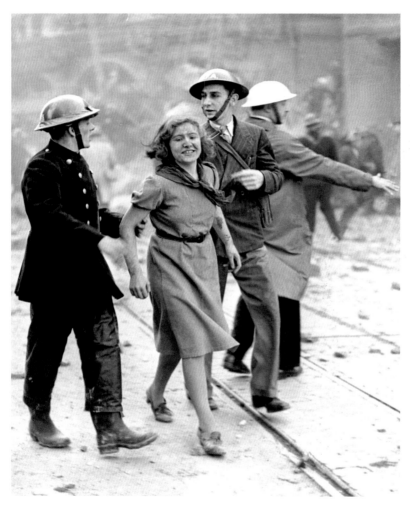

Facing page: London
schoolchildren, from heavily-
bombed districts, take their
treasured belongings to
safer quarters.
1940

A female worker in the
City still smiling after being
rescued from a London
building wrecked by a
bomb dropped in a daylight
Luftwaffe raid.
1940

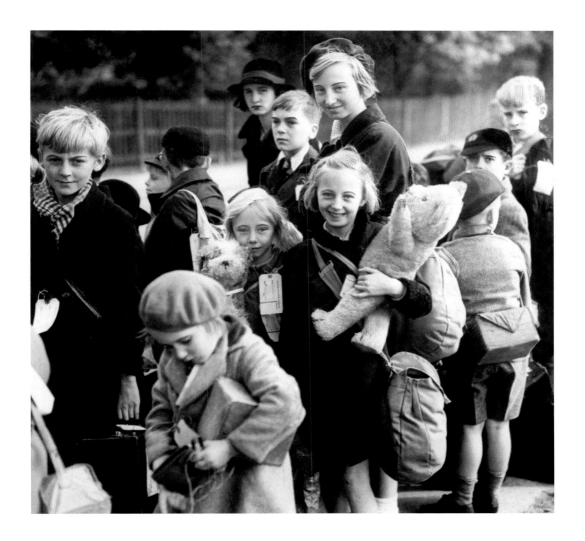

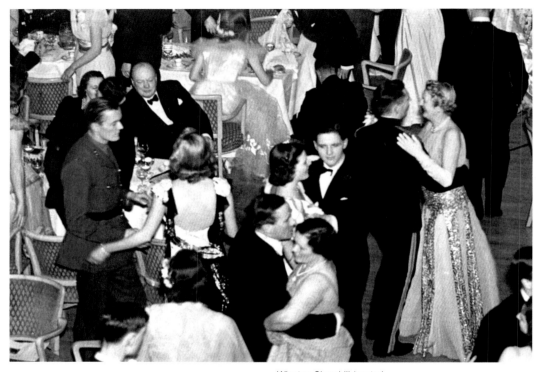

Winston Churchill (seated,
top L) at the Debutantes'
Ball at which his youngest
daughter Mary was one of
the 220 girls who 'came out'.
1940

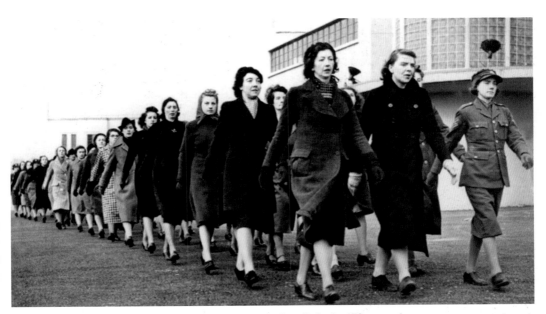

Recruits for the ATS
(Auxiliary Territorial Service)
are put through three weeks
of intensive training at a
former hotel.
1940

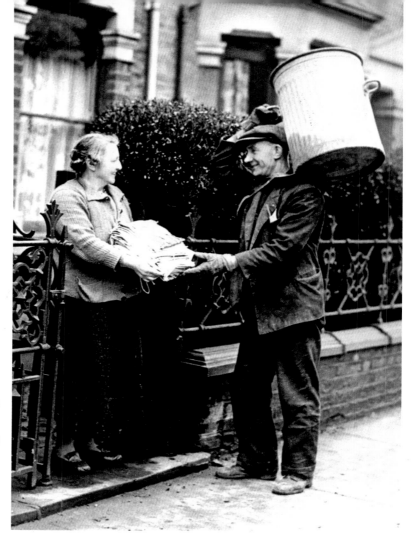

Wartime recycling: East Ham Borough Corporation issued a pamphlet to "encourage the saving of waste materials of all descriptions which are needed for the national war effort. The Corporation undertakes to return all the materials to the industries concerned."
1940

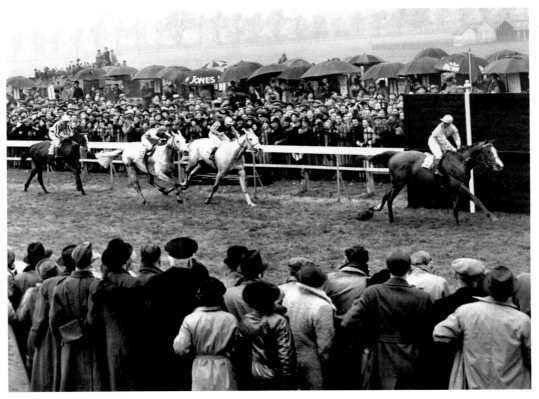

Gordon Richards glances
over his shoulder as his
mount, Quartier-Maitre,
passes the post to win the
Lincolnshire Handicap at
Doncaster.
3rd April, 1940

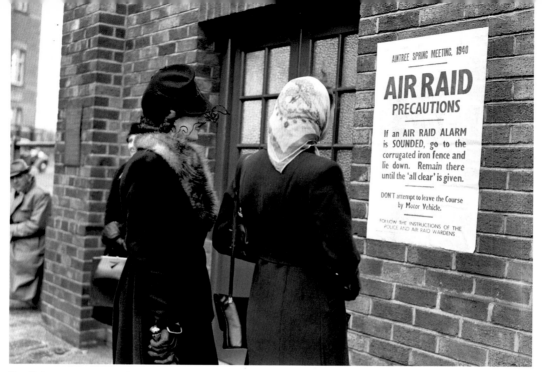

AINTREE SPRING MEETING, 1940

AIR RAID
PRECAUTIONS

If an AIR RAID ALARM
is SOUNDED, go to the
corrugated iron fence and
lie down. Remain there
until the 'all clear' is given.

DON'T attempt to leave the Course
by Motor Vehicle.

FOLLOW THE INSTRUCTIONS OF THE
POLICE AND AIR RAID WARDENS

Two Aintree race-goers read
a notice informing punters
of the air raid precautions at
the Spring Meeting.
5th April, 1940

Facing page: Suitably attired
for their new surroundings
in boots and overalls, four
young children evacuated
to North Cadbury Court,
near Yeovil, Somerset, take
a walk around the farm
attached to the estate.
1st May, 1940

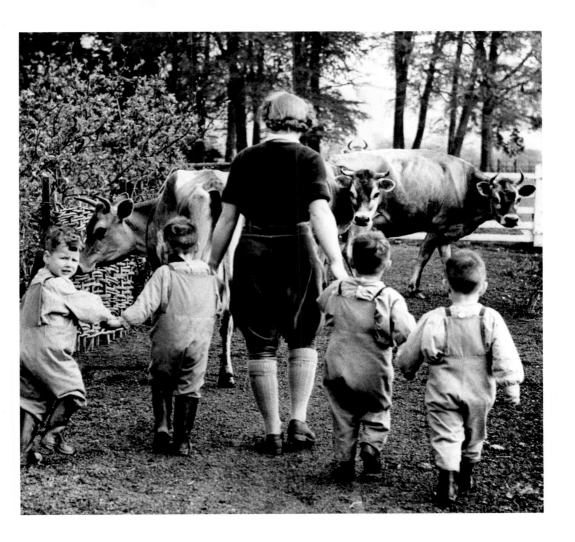

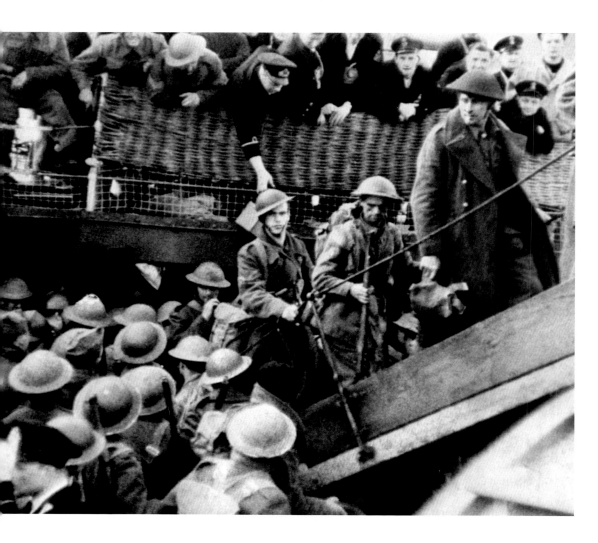

Facing page: British soldiers are assisted by the Royal Navy on their return to England after being evacuated from the beaches of Dunkirk, Northern France, in Operation Dynamo. A total of 338,226 soldiers, mostly from the British Expeditionary Force, were rescued between 19th May and 4th June.
4th June, 1940

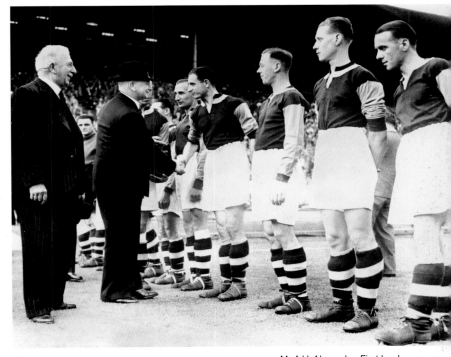

Mr A.V. Alexander, First Lord of the Admiralty, shakes hands with the West Ham United players before the League Cup Final against Blackburn Rovers.
8th June, 1940

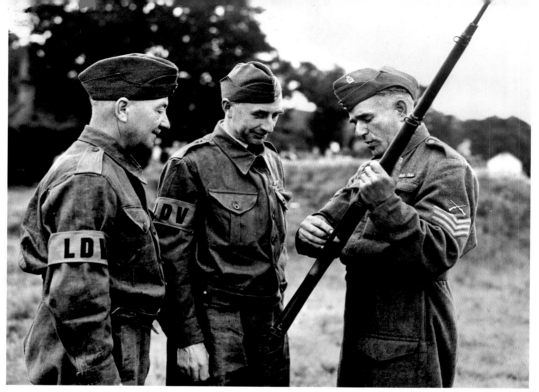

Members of the LDV (Local Defence Volunteers) are introduced to the workings of a rifle.
22nd June, 1940

Facing page: On 24th August 1940, Central London was bombed for the first time during the Second World War. Incendiaries were dropped by the Luftwaffe, causing huge fires in the City of London.
24th August, 1940

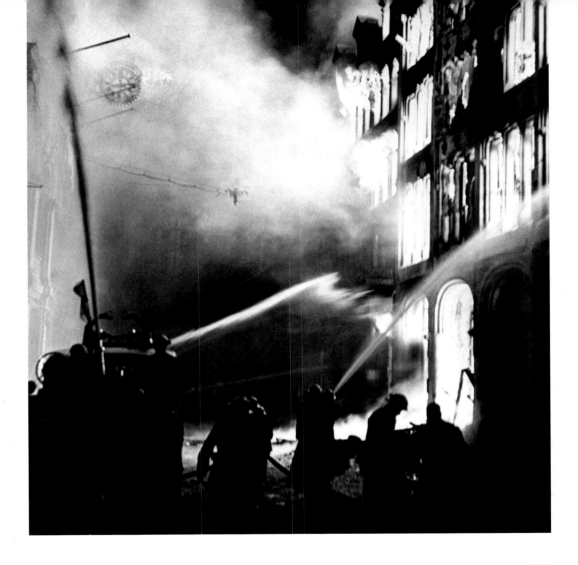

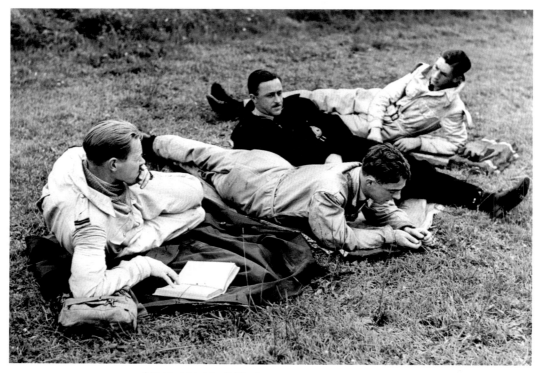

At the height of the Battle of
Britain, Royal Air Force pilots
wait on the airfield for the
instruction to 'scramble'.
1st September, 1940

The 1940s • Britain in Pictures

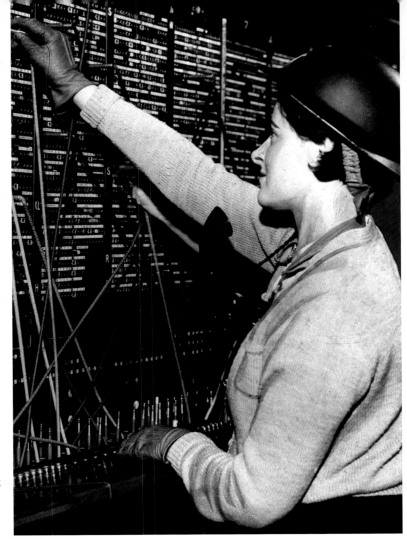

A telephone operator at work on a London switchboard wearing a steel helmet during an air raid.
1st September, 1940

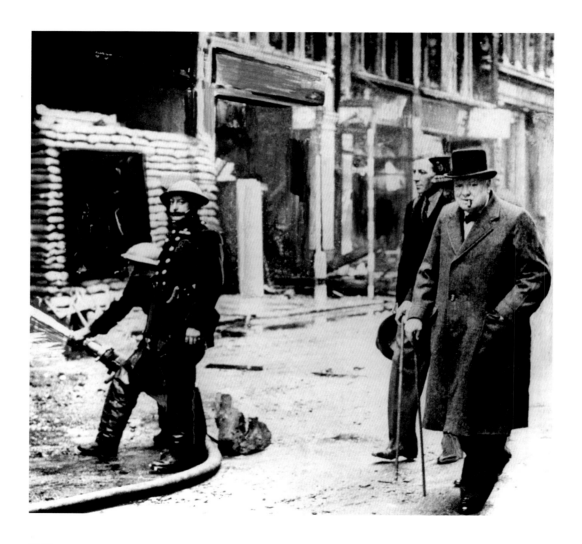

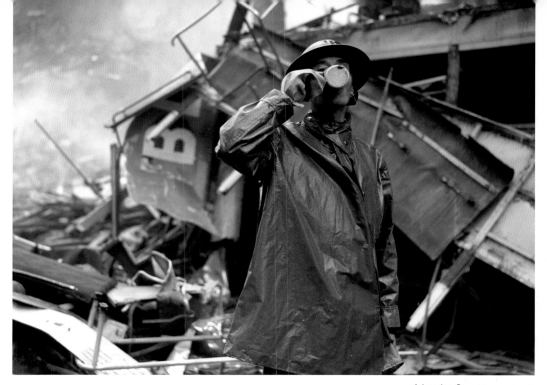

A London fireman pauses briefly for a cup of tea as he works to clear rubble caused by the bombing of Central London during the autumn of 1940.
9th September, 1940

Facing page: Prime Minister Winston Churchill surveys bomb damage during the London Blitz.
September, 1940

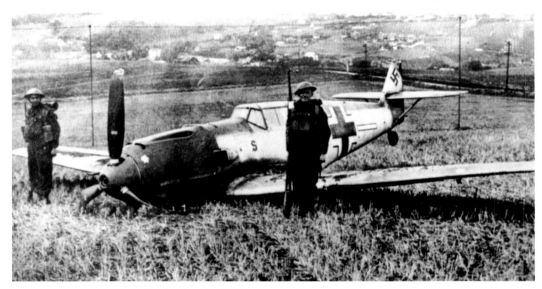

Soldiers from the 9th Bn,
The Devonshire Regiment,
guarding a Luftwaffe
Messerschmitt Bf109E,
which crash-landed following
a Battle of Britain dogfight
near Beachy Head, East
Sussex.
30th September, 1940

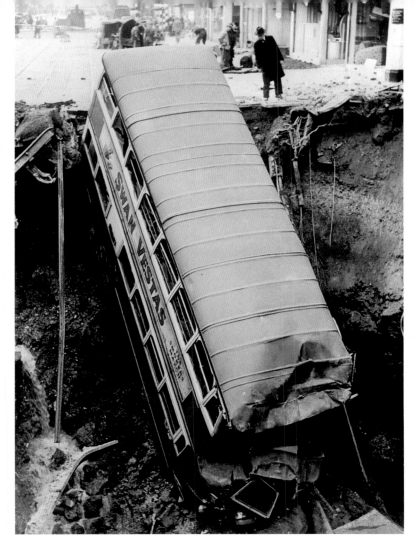

A bus lies in a deep crater
in Balham, South London,
following night-time bombing.
14th October, 1940

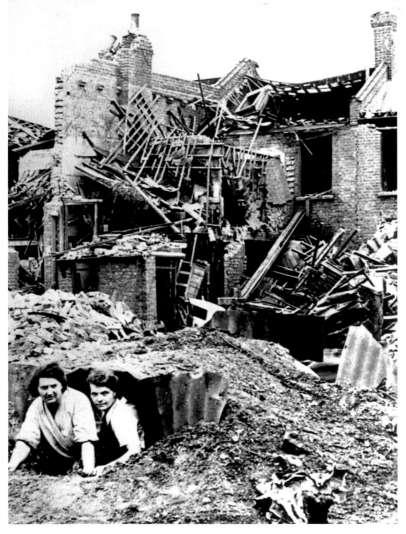

Householders emerging from the Anderson shelter in which they took refuge while their house was destroyed in bombing.
25th October, 1940

The 1940s • Britain in Pictures

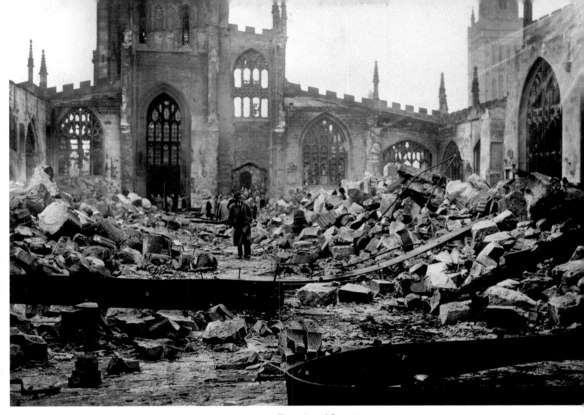

The ruins of Coventry
Cathedral after the medieval
building, and most of the
city's centre, were destroyed
by Luftwaffe bombs during a
single night in the Luftwaffe's
'Baedecker Raids', which
targeted historic sites of little
military significance.
15th November, 1940

A ban on football during periods of Alert was removed and play went on, except in cases of imminent danger. Trained observers kept watch: here Mr R.G. Brown acts as Spotter during a Charlton Athletic v Arsenal match at the Valley.

7th December, 1940

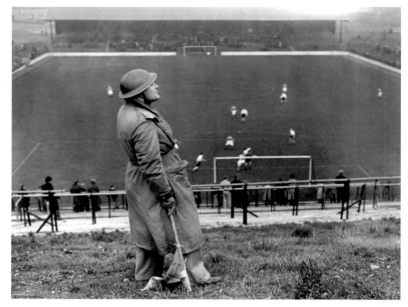

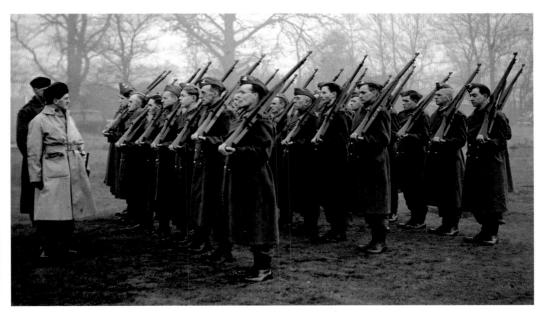

Colonel Chamberlain inspects
the Chislehurst 54th Battalion
of the Kent Home Guard.
15th December, 1940

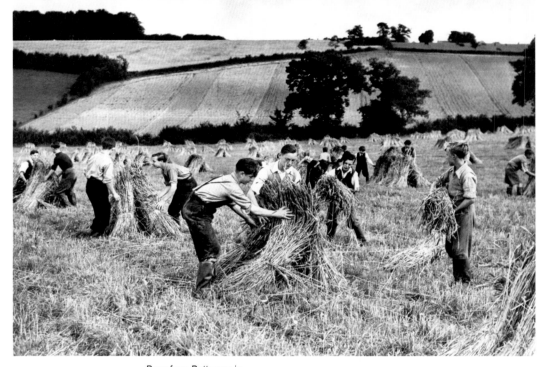

Boys from Battersea in
London help with the harvest
on a Buckinghamshire farm
under the supervision of the
Rev. J.A. Thompson of their
Youth Club.
1941

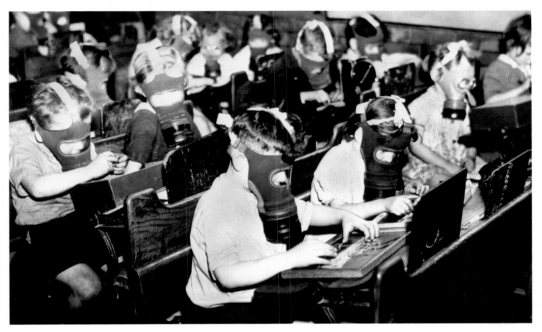

Children were issued with
gas masks at a Clerkenwell,
North London primary
school as a precaution
against gas attack.
1941

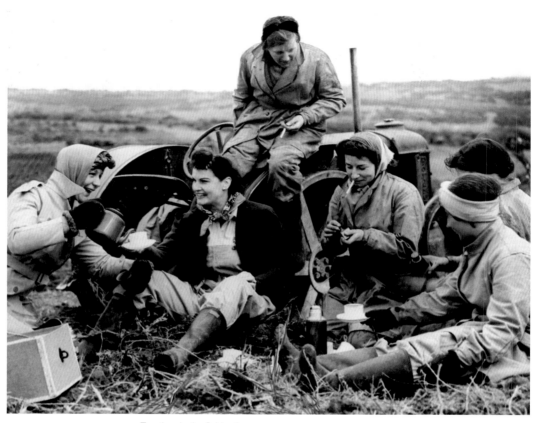

Tea-time in the fields of
Essex, where Land Girls
brought extra acres under
cultivation.
1941

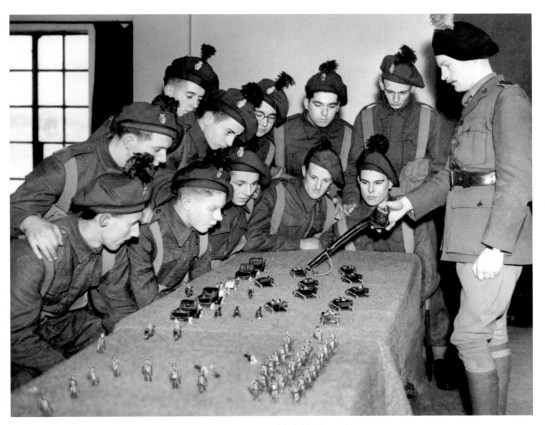

Model tanks and troops are
used to illustrate positions as
an officer, using a shillelagh
as a pointer, lectures to young
Ulstermen in military tactics.
1941

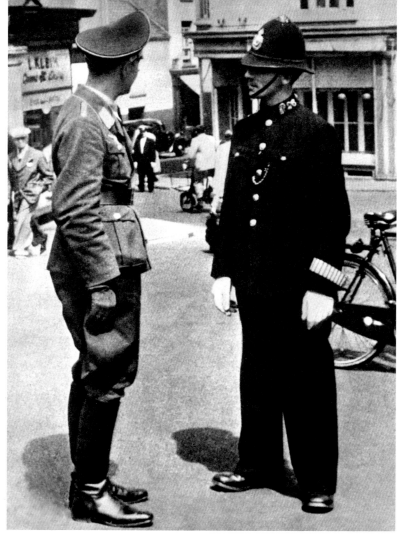

A Luftwaffe officer speaks with a British policeman in St Helier, the capital of the island of Jersey, during the German occupation of the Channel Islands. The Islands were the only part of the British Isles to be invaded by the Germans.
1941

Facing page: Demonstrating the Blitz Spirit, a Londoner still manages to smile while recovering the remains of his belongings from the rubble of his bomb-damaged home.
1941

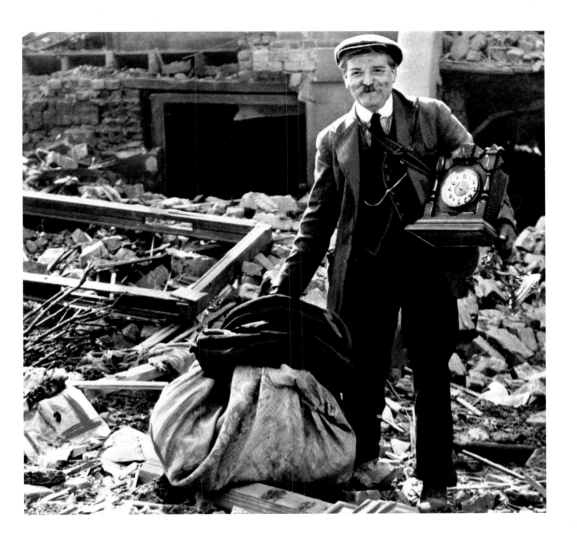

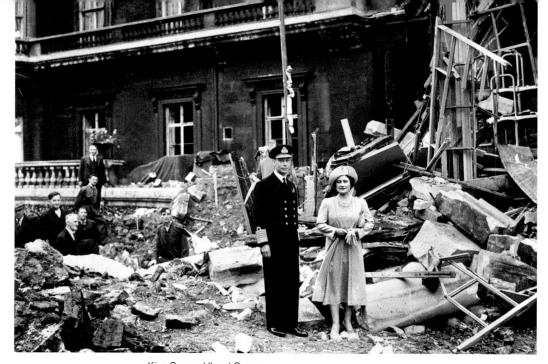

King George VI and Queen
Elizabeth stand amid
bomb damage suffered at
Buckingham Palace.
1941

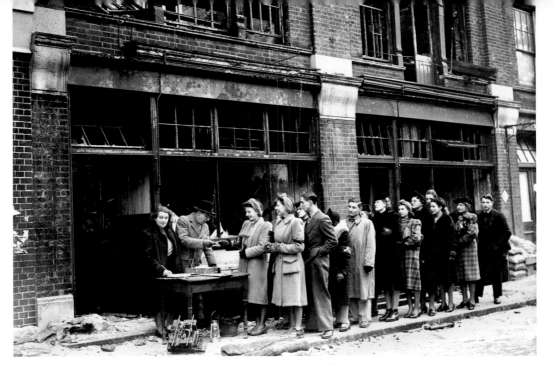

Staff of the Sport and
General Press Agency being
paid their wages outside
their wrecked offices after a
German bombing raid.
1941

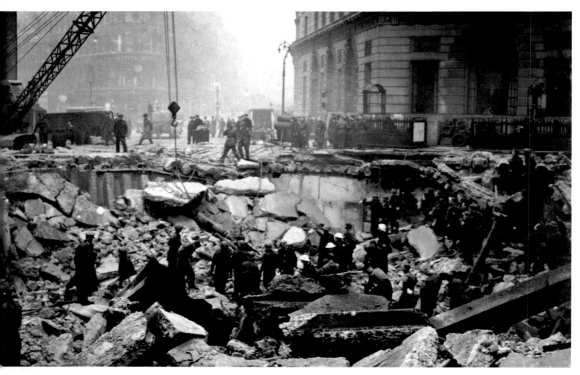

A scene of devastation
after a bomb fell on a
London subway near the
Bank of England.
11th January, 1941

John Mills, in his uniform as a Second Lieutenant, and Miss Hayley Bell at Marylebone, London on the occasion of their marriage during the actor's leave from the army.

16th January, 1941

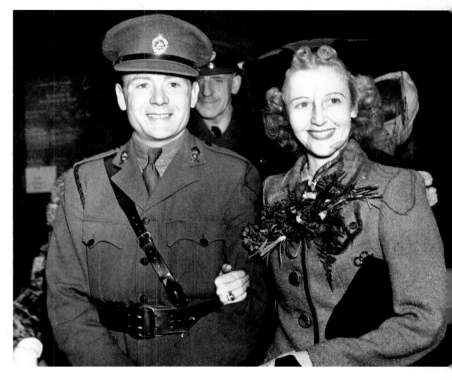

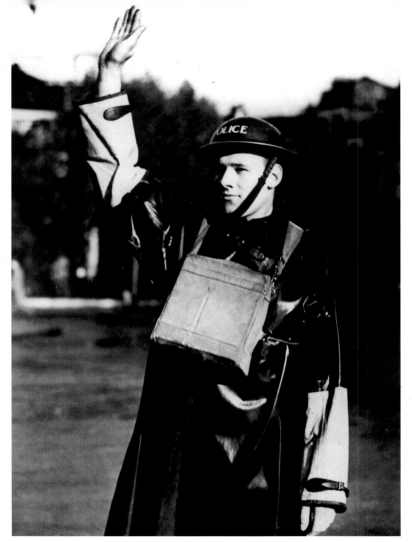

Police Constable Williams on
duty in London.
10th February, 1941

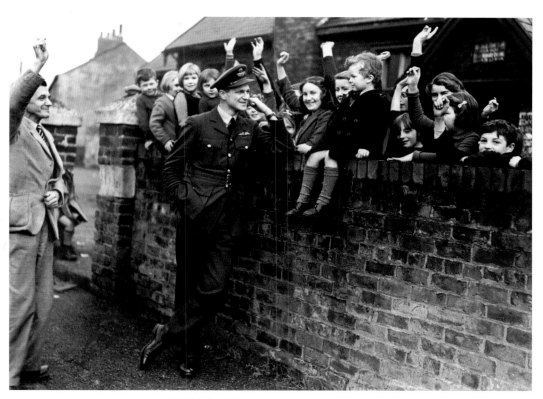

James B. Nicholson, the only
pilot of Fighter Command
to be awarded the Victoria
Cross during the Second
World War, chatting with
village schoolchildren at
Ulleskelf, Yorkshire.
11th March, 1941

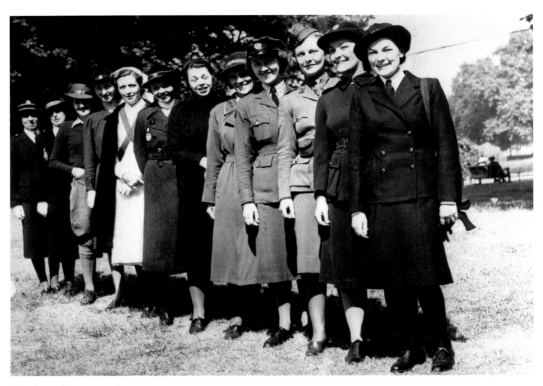

Female service personnel
proudly demonstrate the
multitude of uniforms that
reflects the diverse ways in
which women helped the
war effort.
1941

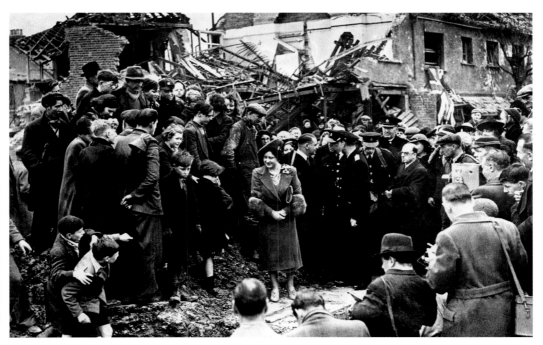

King George VI and Queen
Elizabeth visit the bombed
streets of the East End
of London.
23rd April, 1941

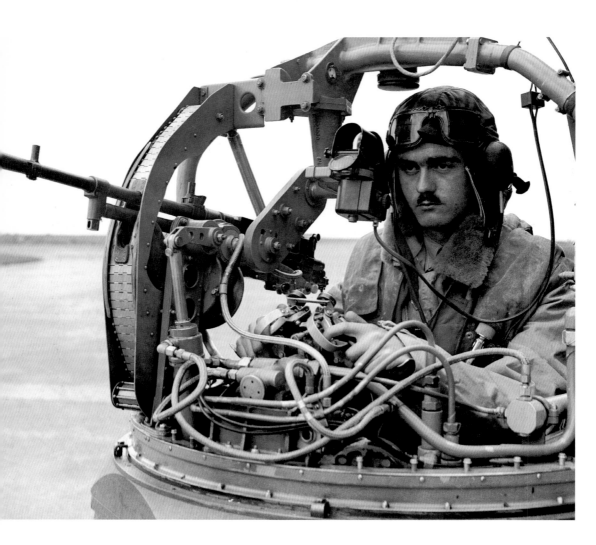

The 1940s • Britain in Pictures

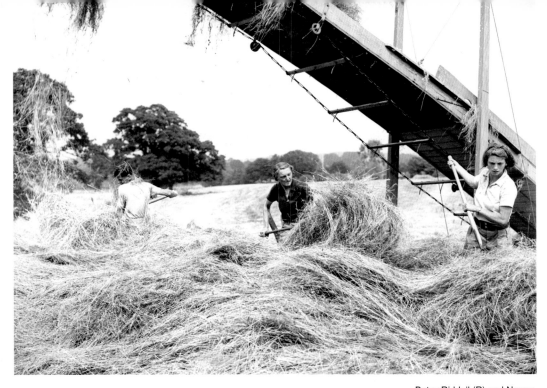

Betsy Riddell (R) and Nancy Smith (C), help with the hay-making on a West Sussex farm as part of the Women's Land Army (Land Girls).
14th July, 1941

Facing page: An air gunner examines his weapon before setting out on a firing exercise at an RAF school of technical training.
27th May, 1941

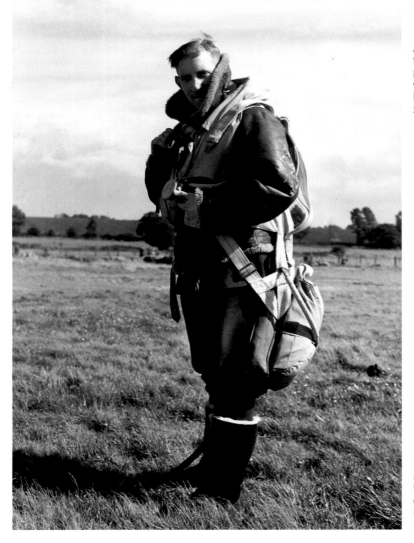

An RAF fighter pilot wearing flying gear, including the parachute on which he would sit in the cockpit of his aeroplane.
28th August, 1941

Facing page: Robert Yoghill and William Williams, both formerly of Islington, London evacuated to a farm at Porthcurno, Cornwall.
1st September, 1941

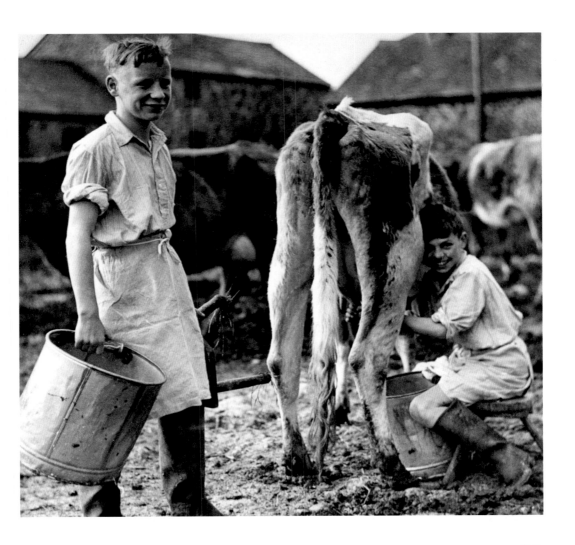

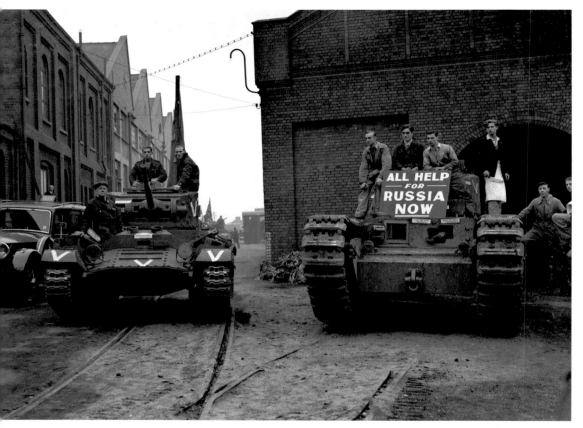

Getting ready to help a new ally – these tanks are the first to be sent from Britain to the battlefields of Leningrad, Moscow and Odessa following Hitler's invasion of Russia in the summer of 1941.

22nd September, 1941

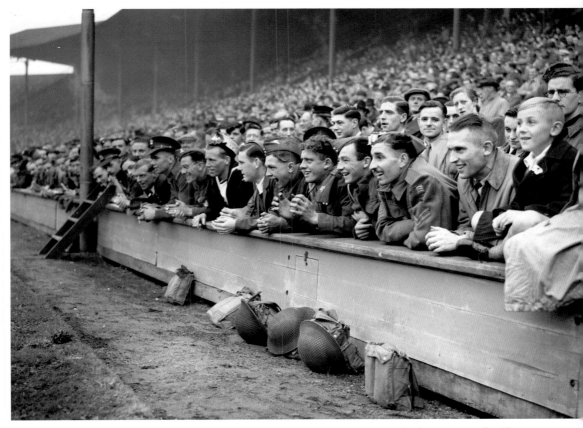

Servicemen have a front line view of the football match between England and Scotland at Wembley Stadium.
4th October, 1941

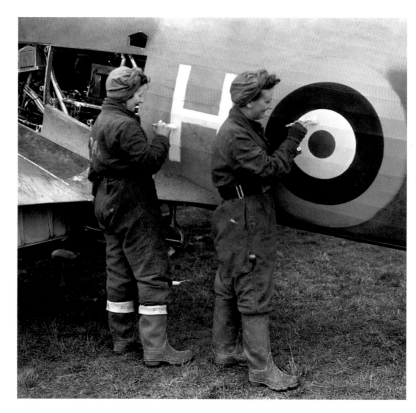

Women's Auxiliary Air Force (WAAF) flight mechanics painting the markings on an aeroplane.
13th December, 1941

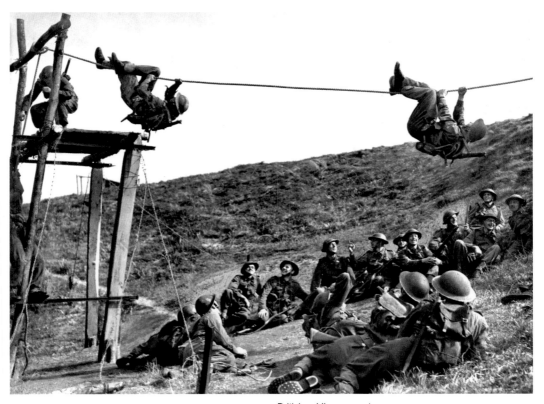

British soldiers are put
through training exercises at
a Weapons Training School
in the Southern Command
during the Second World War.
1942

Harold MacMillan served in the wartime coalition government as the Parliamentary Secretary to the Ministry of Supply from 1940 to 1942 and was tasked to provide armaments and other equipment to the British Army and Royal Air Force. Macmillan travelled the country to co-ordinate production and increase the supply and quality of armoured vehicles. In 1942 he was appointed Under-Secretary of State for the Colonies, in his own words, *"leaving a madhouse in order to enter a mausoleum"*.
1942

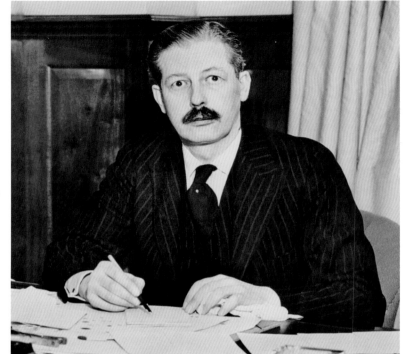

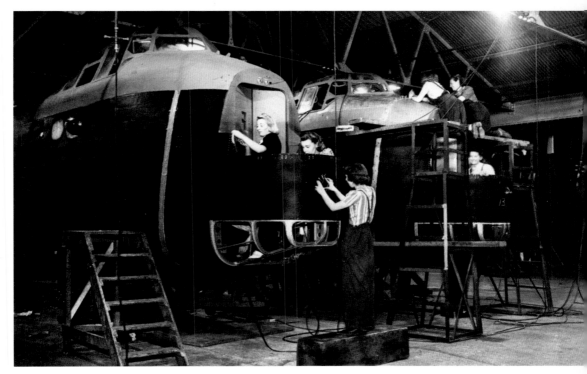

Women hard at work during the construction of Britain's giant bomber, the *Stirling*. The enormous aircraft was the RAF's first four-engined bomber and carried a crew of seven.
1942

Workers of the Women's
Land Army with a spaniel
during a lunch break on a
farm in Sevenoaks, Kent.
1942

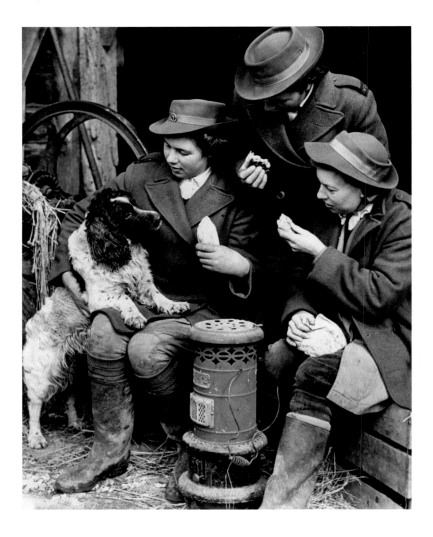

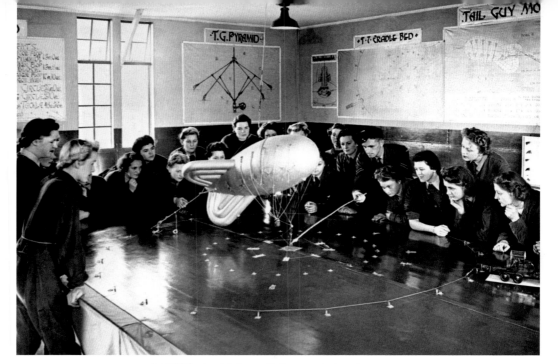

An RAF Corporal delivers a lecture on mooring a barrage balloon, to members of the WAAF. The balloons were designed to defend vulnerable sites against low-level attack by aircraft, either by snaring them in their tether cables, or by forcing them to fly higher into the range of anti-aircraft fire.
1942

A Warrant Officer of the 14/20th King's Hussars with a cooking equipment and supplies at the Army Catering Corps Training Centre in Aldershot. The school taught army personnel as well as members of the Voluntary Aid Detachments and the ATS.
1942

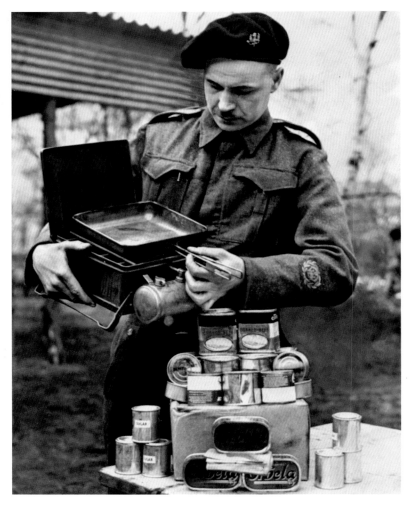

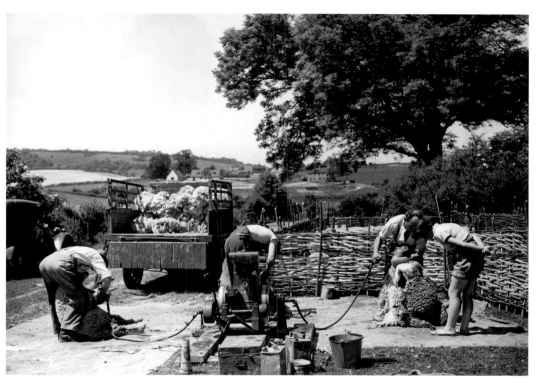

A Land Girl (R) takes a
lesson in sheep shearing
at Pyecombe, near
Hassocks, Sussex.
22nd April, 1942

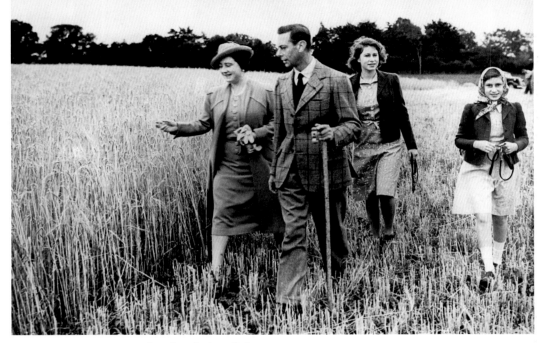

Away from the turmoil of
the Second World War,
King George VI and Queen
Elizabeth walk in a field with
their daughters, Princess
Elizabeth and Princess
Margaret (R).
30th September, 1942

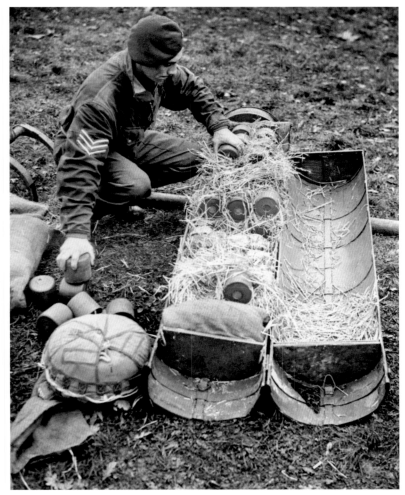

A Sergeant of the Royal Army Service Corps packs a canister, which is to be dropped from an aeroplane. The canisters deliver food, medical supplies, fuel, ammunition or weaponry. **1943**

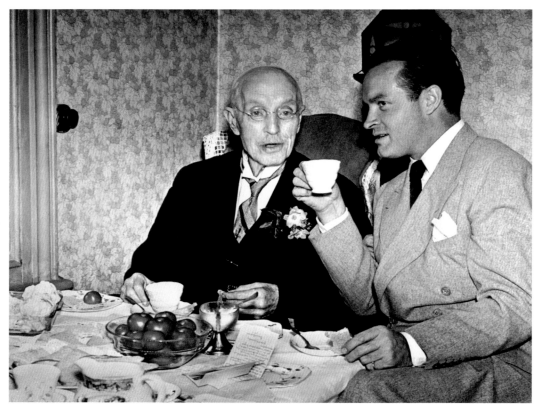

American entertainer
Bob Hope enjoys a cup
of tea during a visit to his
grandfather.
1943

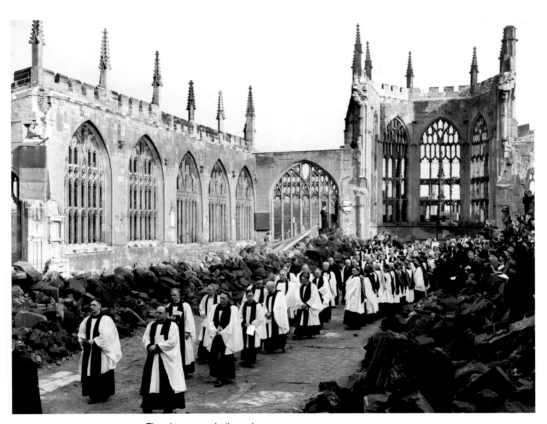

The clergy parade through the bombed ruins of Coventry Cathedral after the enthronement of the Bishop of Coventry, the Right Reverend Neville Vincent Gorton.
20th February, 1943

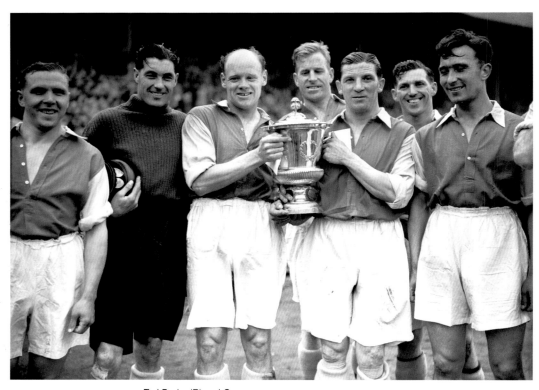

Ted Drake (R) and George
Male (C) of Arsenal holding
the Football League
South War Cup after the
presentation by the Duchess
of Gloucester. They won the
match against Charlton 7–1.
1st May, 1943

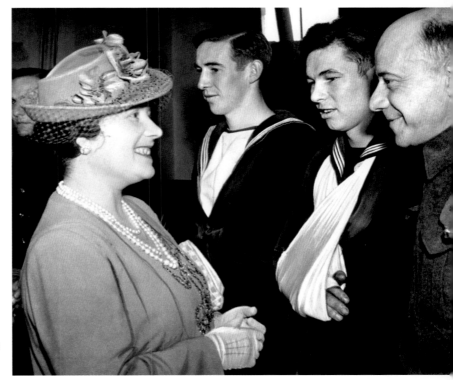

Her Majesty the Queen talking to Corporal Henry Savaria and A.B. Grant, with his arm in a sling, during a visit to the Church Army Services Club in Marylebone Road, London.

14th May, 1943

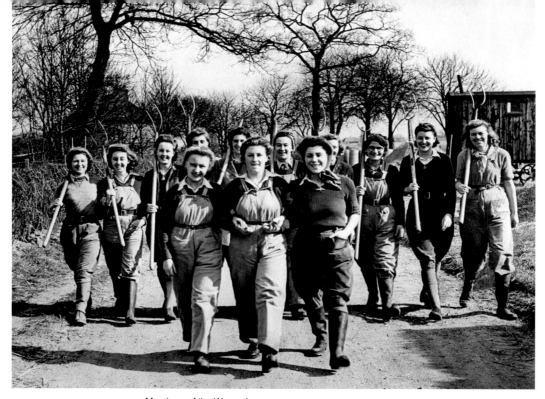

Members of the Women's
Land Army from various
parts of the country, some
with pitchforks over their
shoulders.
1st November, 1943

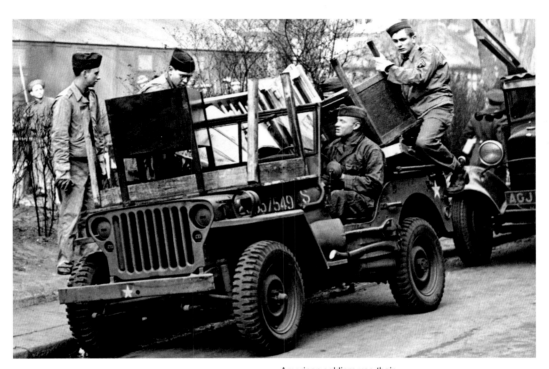

American soldiers use their
jeep to help in the rescue
work and fire fighting during
the German bombing raids
on London.
1944

American soldiers stationed
in the London area help in
the rescue work during a
German raid on the city.
1944

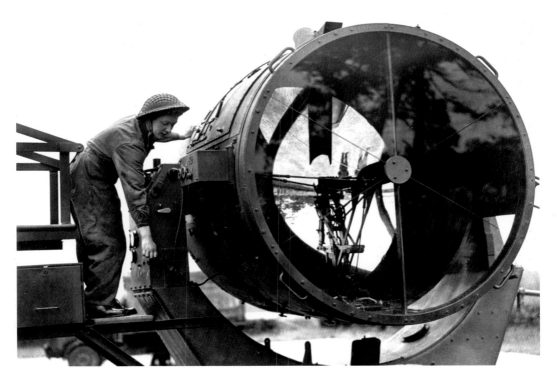

Betty Wood, a former Leeds
factory worker, 'striking up
the Arc', a searchlight.
1944

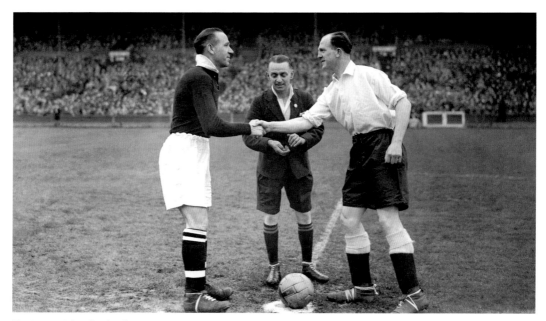

The two captains, Scotland's
Matt Busby (L) and
England's Stan Cullis (R),
shake hands before a match,
as referee W.E. Wood
prepares to toss the coin.
19th February, 1944

A family group taken on Princess Elizabeth's 18th birthday. Back, L–R: Duke of Gloucester, Princess Alice of Gloucester, Princess Margaret, Princess Mary, Princess Marina, Earl of Harewood. Front, L–R: Queen Mary, King George VI, Princess Elizabeth and Queen Elizabeth.
21st April, 1944

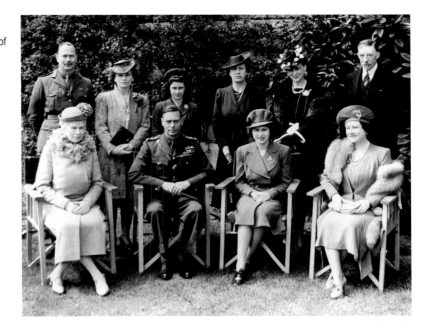

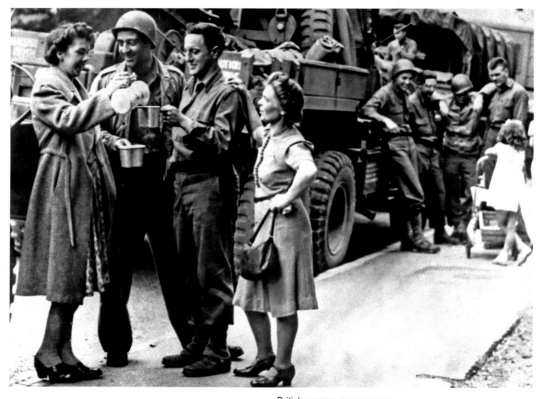

British women pour a mess tin of tea for men from an American convoy heading for the south coast of England during the build-up to the Normandy landings (D-Day) of June 1944.
1st June, 1944

The 1940s • Britain in Pictures

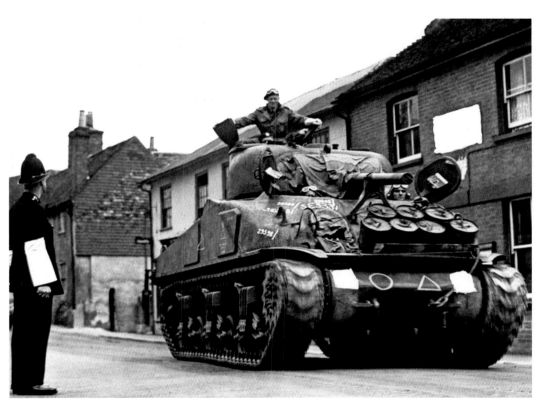

A British Army Sherman Tank rumbles down a street on its way to a south coast port prior to the Normandy landings. The wartime Censor has obliterated a sign in the background as well as the tank's unit markings.
1st June, 1944

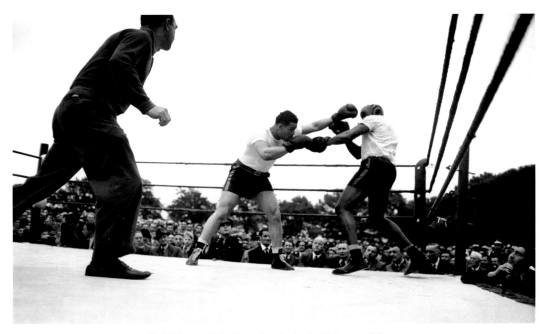

World Heavyweight Champion Joe Louis (L) throws a left at fellow American Tommy Thompson (R) during an exhibition bout. As part of a morale boosting exercise Louis, who had enlisted in the US Army, took part in a celebrity tour of more than 21,000 miles and staged 96 boxing exhibitions before two million soldiers, including England.

1st June, 1944

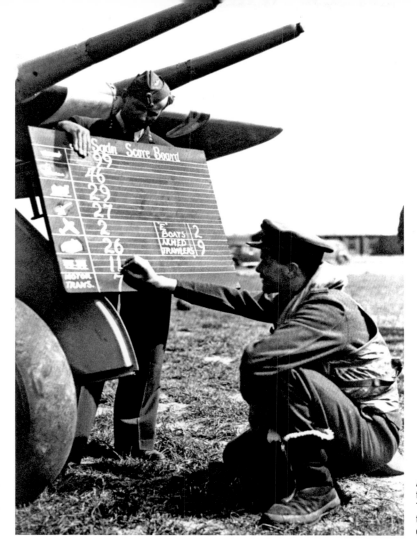

An RAF pilot chalks up the score of his Hawker Typhoon Mk1B aircraft on the Squadron board.
6th June, 1944

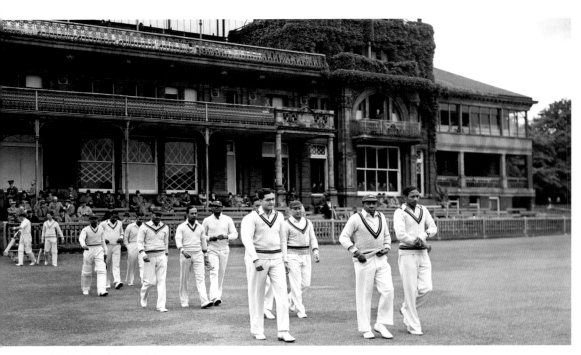

West Indies cricket captain
Learie Constantine
(second R) leads his team
out at Lord's for a match
against England.
16th June, 1944

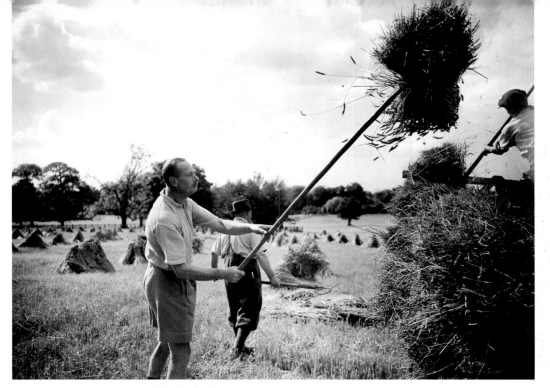

The Duke of Gloucester
helping with the gathering
of the harvest at his
Barnwell Manor Farm,
Northamptonshire.
29th August, 1944

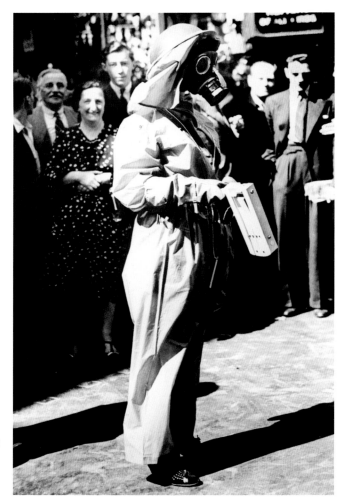

A woman acting as a warden in Golden Square during a gas attack exercise in West End London.

6th September, 1944

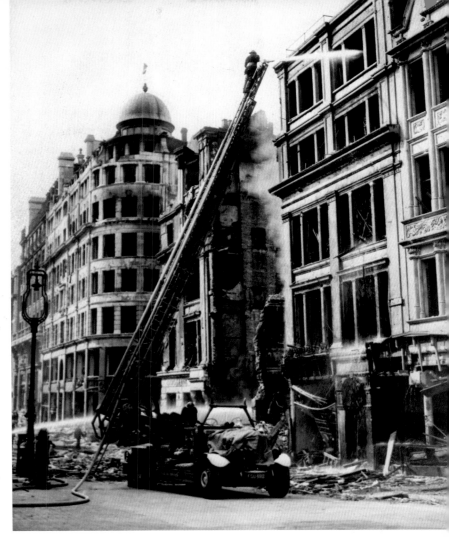

Fire crews deal with damage
caused by German bombs
dropped in Central London
the previous night.
8th September, 1944

The Oval cricket ground was
used as a prisoner of war
camp during the Second
World War.
29th November, 1944

Facing page: Princess
Elizabeth receives vehicle
maintenance instruction on
an Austin 10 Light Utility
Vehicle while serving with
No 1 Motor Transport
Training Corps (MTTC) at
Camberley, Surrey.
1945

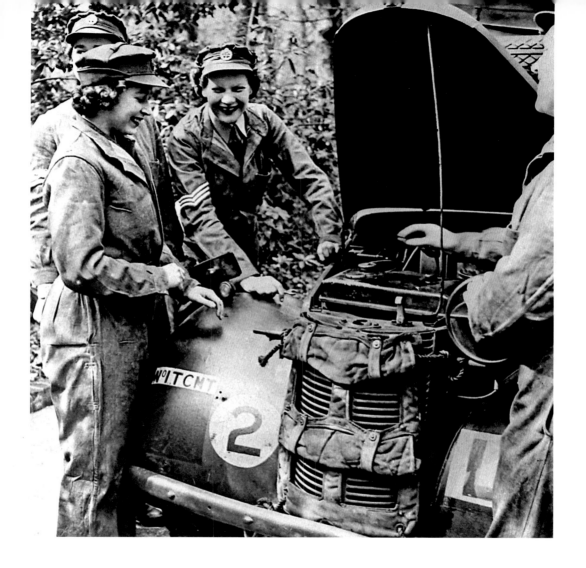

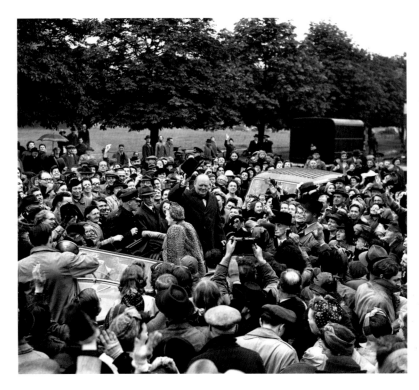

Winston Churchill, with his wife Clementine, campaigning at Buckhurst Hill in his Essex constituency raises his hat to the crowds.
26th January, 1945

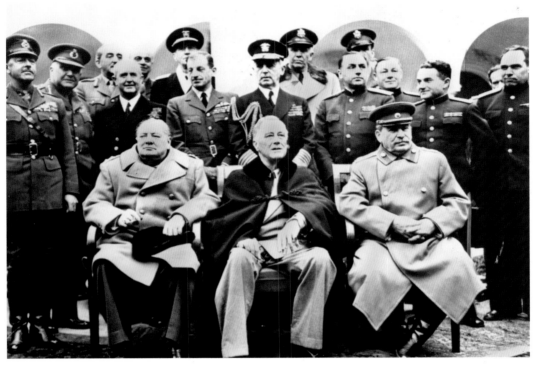

L–R: Winston Churchill,
US President Franklin
D. Roosevelt and Soviet
leader Josef Stalin with their
advisers at Yalta, in the
Crimea, where the Allies
decided the future of post-
war Europe.
4th February, 1945

Smithfield Market, London, soon after the explosion of a German V-2 rocket. One hundred and ten people were killed in the incident, one of the worst tolls from the V-weapons.

8th March, 1945

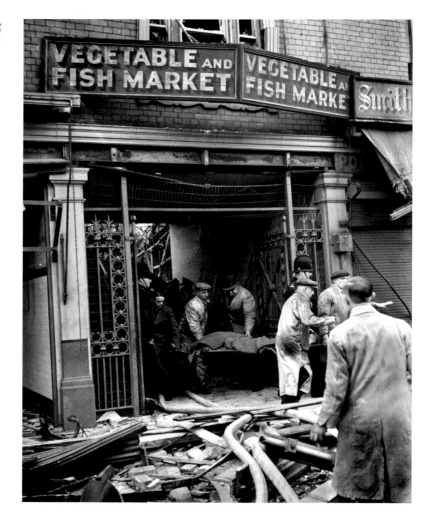

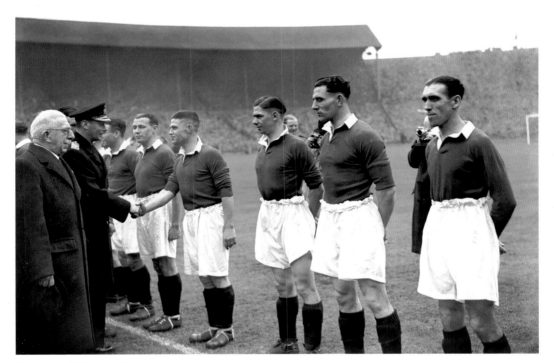

King George VI (second L) is introduced to the Chelsea players before the Football League (South) Cup Final.
7th April, 1945

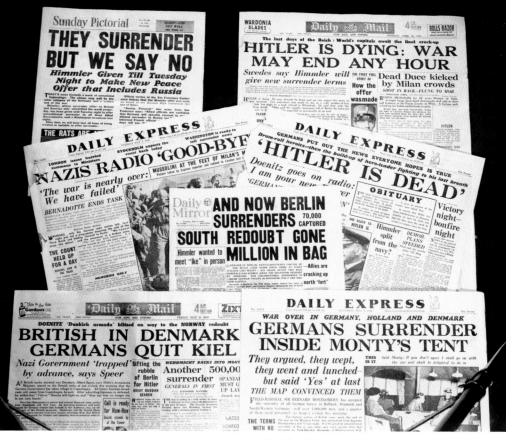

Headlines from a week's newspapers (29th April–5th May, 1945), during one of the momentous periods of the Second World War.

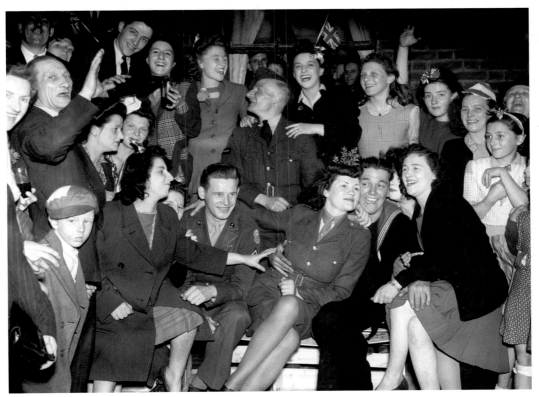

VE Day celebrations in the
East End of London, marking
the end of the Second World
War in Europe.
8th May, 1945

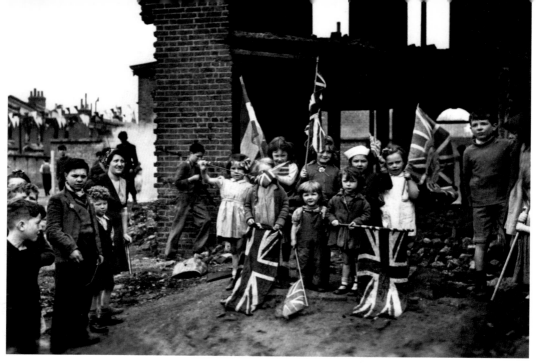

Young London residents
celebrate VE Day amid
the ruins of their homes in
Battersea.
8th May, 1945

Facing page: crowds
massed in Trafalgar
Square and up The Mall to
Buckingham Palace, where
King George VI and Queen
Elizabeth, accompanied
by Prime Minister Winston
Churchill, appeared on the
balcony of the palace before
the cheering crowds.
8th May, 1945

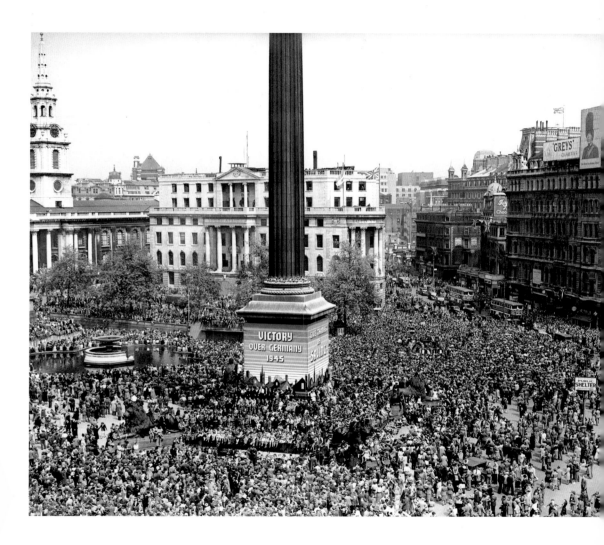

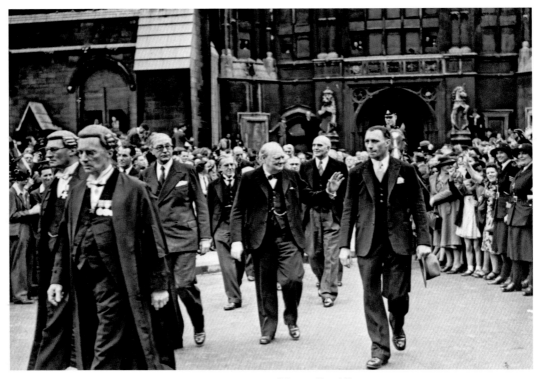

Winston Churchill
acknowledges the crowd
as he leaves the Houses of
Parliament after the news of
the defeat of Nazi Germany.
8th May, 1945

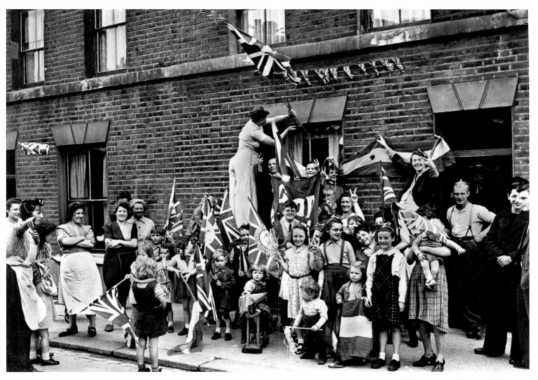

On the day Winston Churchill broadcast to the nation that the war with Germany had been won, more than one million people celebrated in the streets to mark the end of the European conflict.

8th May, 1945

During their tour of the East End of London, King George VI and Queen Elizabeth visit Vallence Road, Stepney, which was badly damaged during a German rocket attack.
10th May, 1945

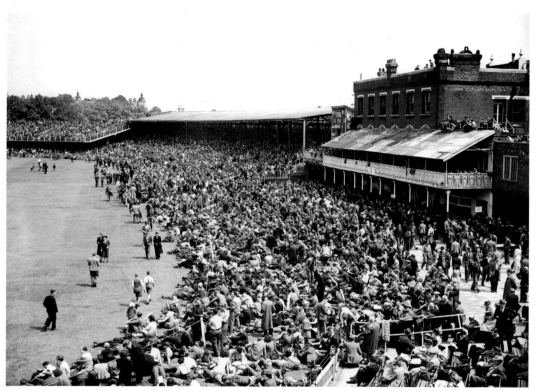

Members of the capacity
crowd spill onto the field of
play during the England v
Australia cricket match at
Lord's, St John's Wood.
21st May, 1945

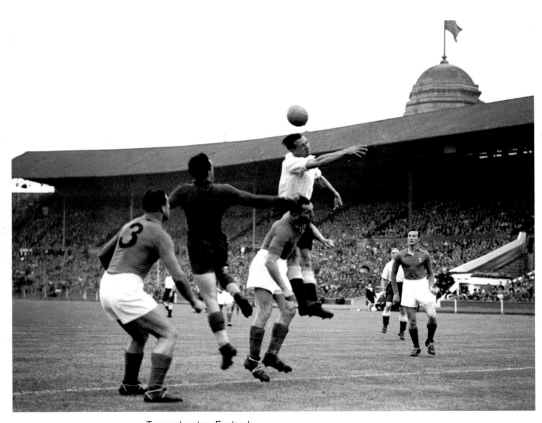

Tommy Lawton, England
captain, heading the ball in
the French goal area during
a friendly match at Wembley.
26th May, 1945

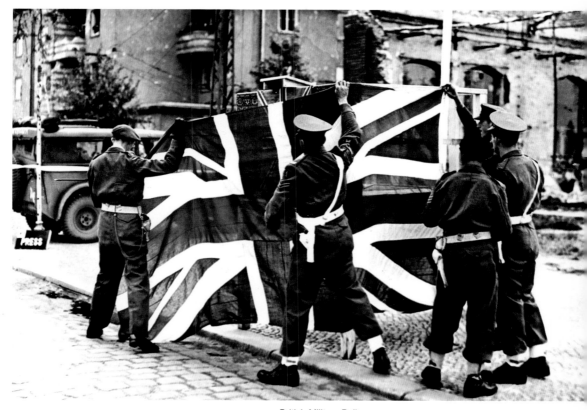

British Military Policemen
prepare to hoist the Union
Jack to receive the official
entry of the British Army into
Berlin, the German capital.
30th May, 1945

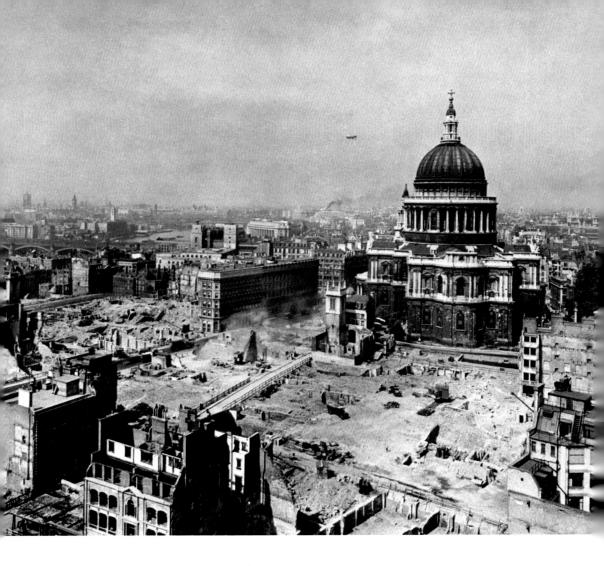

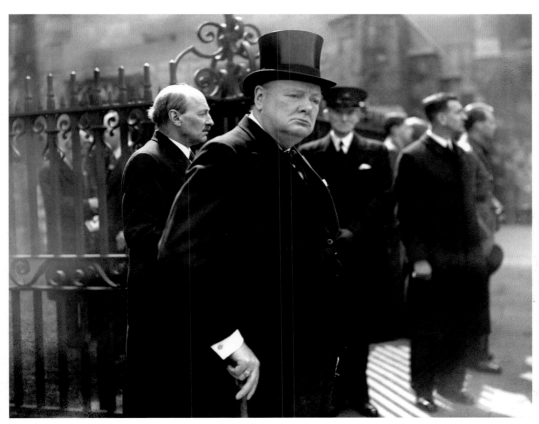

Facing page: St Paul's
Cathedral, where work
begins to repair the damage
caused by Luftwaffe
bombing raids on London.
1st June, 1945

Winston Churchill leaving
Westminster Abbey, London,
after the memorial service
for the late Prime Minister
Lloyd George.
1st June, 1945

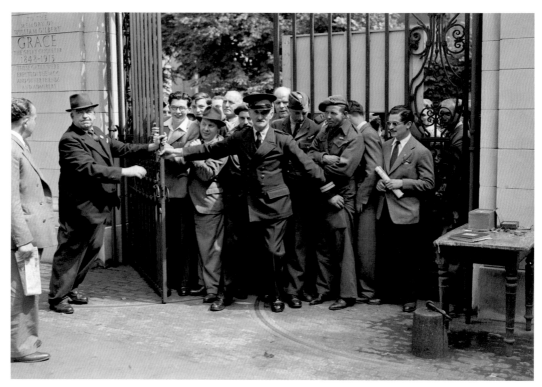

Lord's officials hold back
spectators who tried to force
the Grace gates open, after
being locked out due to
huge interest in the cricket
match between England and
Australian Services. The
visitors won by four wickets.
14th July, 1945

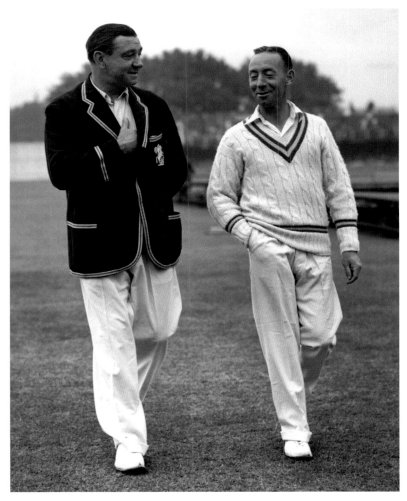

Australia's captain Lindsay
Hassett (R) talks to England
captain Wally Hammond
(L) before the start of play
at Lord's in the England v
Australian Services match.
14th July, 1945

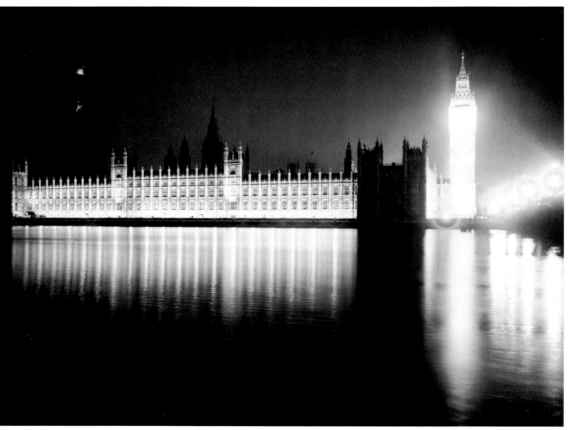

The Houses of Parliament floodlit on VJ Day, the name
chosen for the day on which the Surrender of Japan
occurred, effectively ending the Second World War.
15th August, 1945

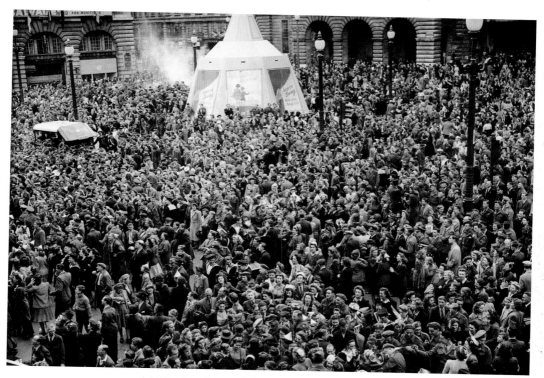

Jubilation from the crowds in
Piccadilly Circus, London on
VJ Day.
15th August, 1945

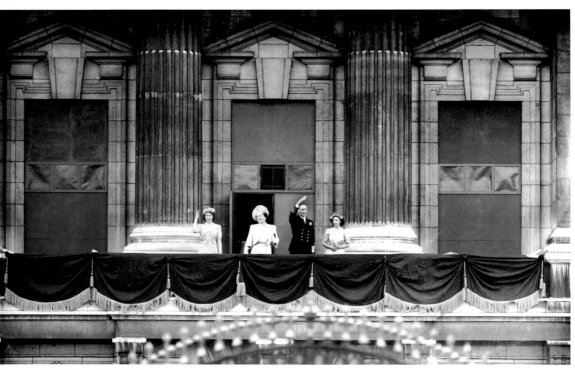

King George VI with the
Queen, Princess Elizabeth
and Princess Margaret on
the balcony of Buckingham
Palace on VJ Day.
15th August, 1945

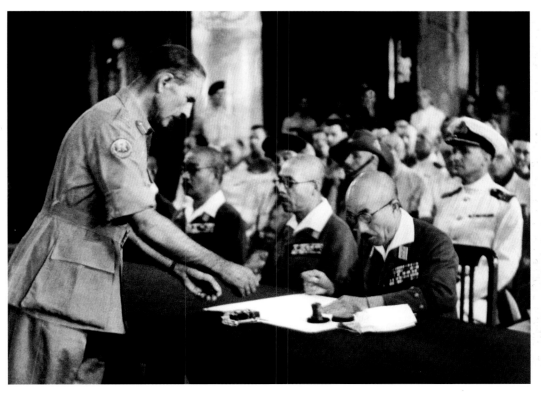

Lord Louis Mountbatten,
Commander of the Allied
forces in South East Asia (L),
presides as General Itagaki
of the Japanese Imperial
Army signs the surrender
document in Singapore.
12th September, 1945

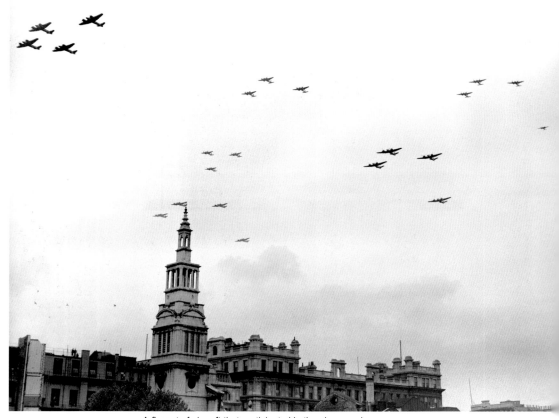

A flypast of aircraft that participated in the air campaign
waged by the Luftwaffe against the United Kingdom during
the summer and autumn of 1940, on the first Battle of Britain
Day after the end of the Second World War, which has been
celebrated annually ever since.
15th September, 1945

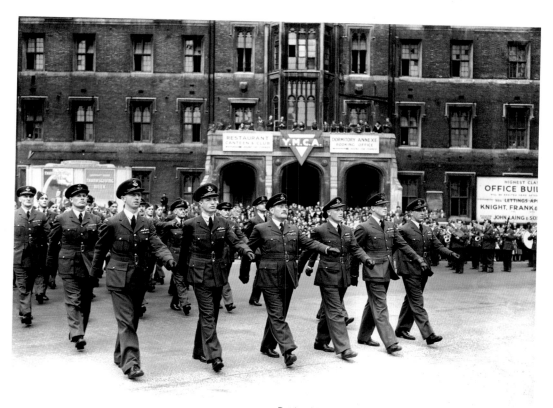

Battle of Britain heroes
march to Westminster Abbey
for a Remembrance Service
dedicated to those pilots
and crew who lost their lives
during the campaign.
16th September, 1945

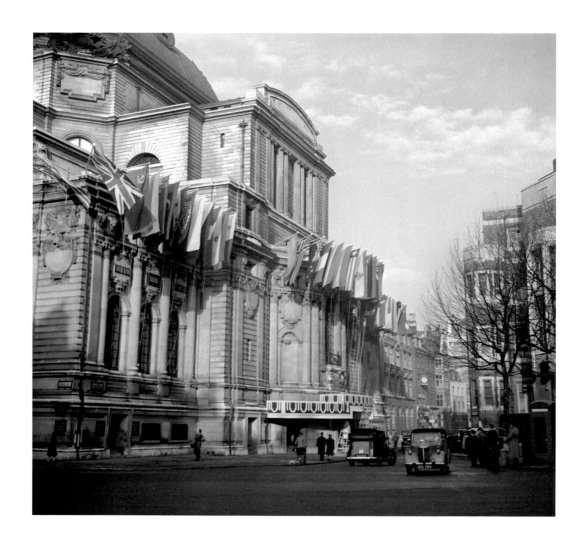

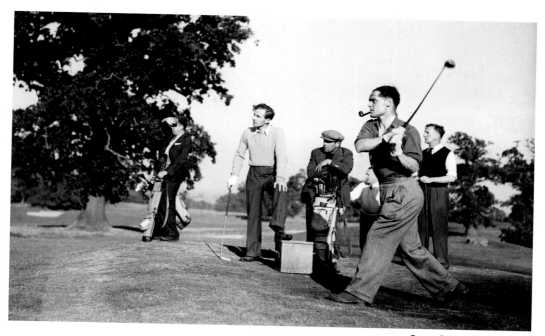

Facing page: Fifty one flags of the United Nations flying outside Central Hall, Westminster before the Charter of the United Nations was ratified by the five country members of the Security Council on 24th October. The Methodist church was later to host the first meeting of the United Nations General Assembly on 10th January, 1946. In return for the use of the hall, the Assembly voted to fund the repainting of the walls of the church in a light blue.
10th October, 1945

Group Captain Douglas Bader (R) drives from the tee, watched by his golf partner Wing Commander P.B. Lucas (second L). Bader, an RAF fighter ace during the Second World War lost both his legs in an aerobatic accident in December 1931, but retook flight training and on the outbreak of war returned to the RAF as a pilot.
10th October, 1945

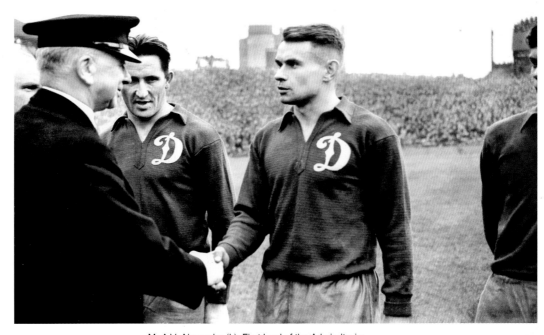

Mr A.V. Alexander (L), First Lord of the Admiralty, is introduced to the Dynamo Moscow players before a football match against Chelsea during the Soviet team's goodwill tour of Britain. The team of unknowns put on an admirable performance, drawing 3:3 against Chelsea, later winning 10:1 over Cardiff City, beat Arsenal 4:3 in a match played in thick fog, and finally, drew 2:2 with Rangers.

13th November, 1945

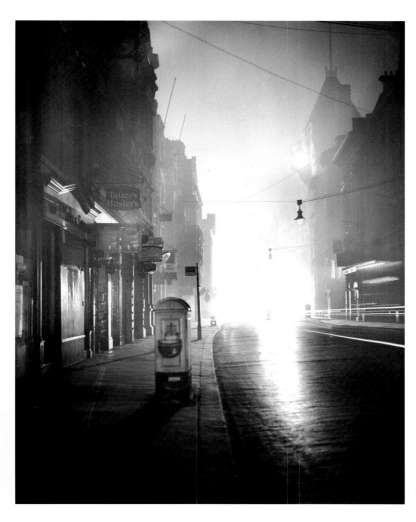

Fleet Street, London during a blackout as a result of a strike by several London gas works.
25th November, 1945

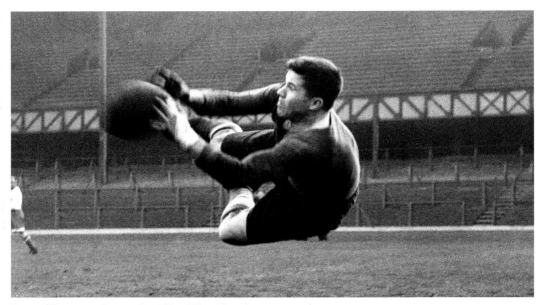

Dynamo Moscow goalkeeper Alexei 'Tiger' Khomich makes
a flying save during training at the Ibrox Stadium, Glasgow
the day before the Soviet team's match against Rangers,
which resulted in a 2:2 draw.
27th November, 1945

Facing page: Harlequins'
C.M. Horner (with ball) is
tackled by Leicester's Tom
Berry (C) in the rugby union
match played at The Stoop
stadium, Twickenham,
London.
1st December, 1945

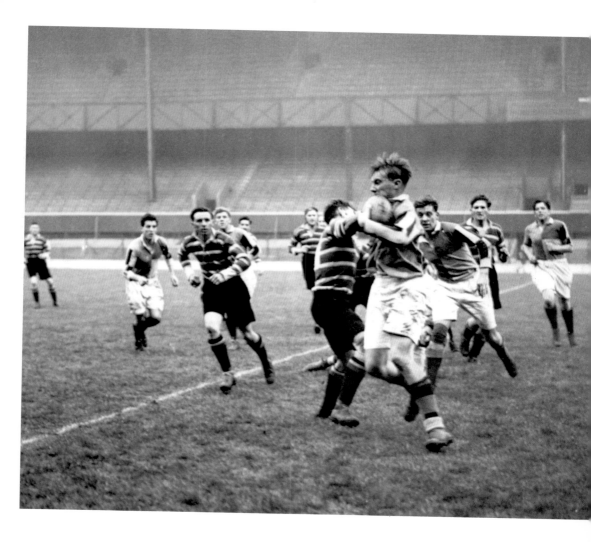

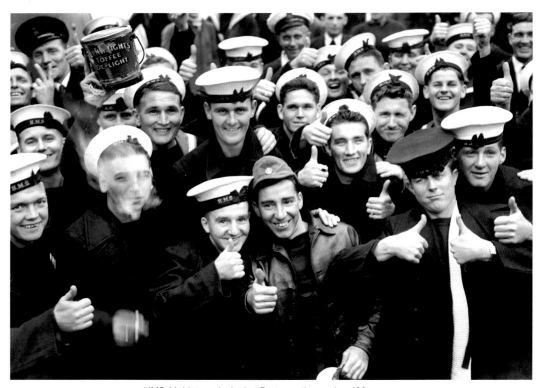

HMS *Maidstone* docked at Portsmouth carrying 400 ex-prisoners of war, many of whom are survivors from the heavy cruiser HMS *Exeter*, sunk off Java by the Japanese. Here the sailors give the thumbs-up to show their pleasure at being home.
11th December, 1945

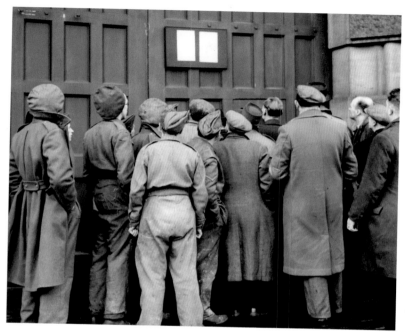

A crowd of civilians and servicemen gather to view the notice posted on the gates of Wandsworth Prison in London announcing the execution of British fascist John Amery after he admitted treason. Amery, son of Leo Amery and brother of Julian Amery, both Members of Parliament and Conservative cabinet ministers, had proposed to the Wehrmacht the formation of a British volunteer force (that became the British Free Corps) and made recruitment efforts and propaganda broadcasts for Nazi Germany.

19th December, 1945

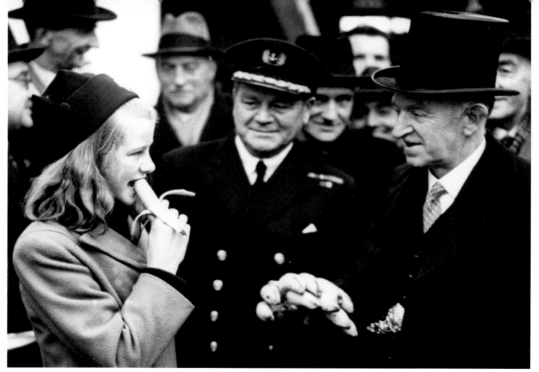

Twelve year old Daphne
Philips eats the first banana
to arrive in Britain after
the war, given to her by
Alderman James Owen JP,
Lord Mayor of Bristol, on the
quayside at Portsmouth.
30th December, 1945

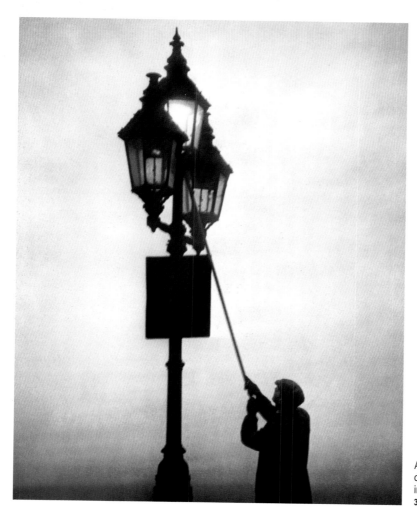

A lamplighter on his rounds
on a foggy New Year's Eve
in Blackfriars, London.
31st December, 1945

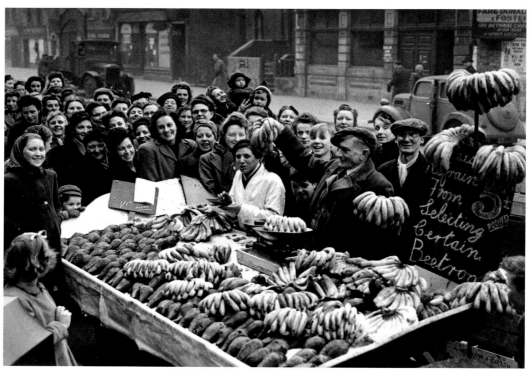

Bethnal Green's greengrocer
is surrounded by housewives
queuing for much awaited
bananas, which have been
scarce since the beginning
of the war. Rationing did not
end in the United Kingdom
until the 1950s.
1946

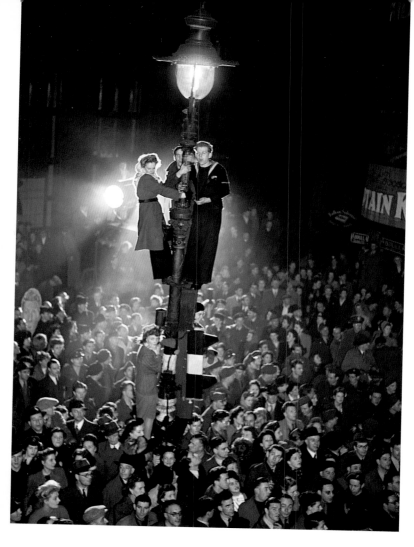

Thousands of people singing 'Auld Lang Syne' swept military and civilian police off their feet as they tried to gatecrash Rainbow Corner, the American Red Cross Club at 23 Shaftesbury Avenue, London on the day it closed down. Service clubs such as this offered not only meals and recreational activities but also overnight accommodation, barber shops and laundries. The Rainbow Corner, whose doors never shut, served up to 60,000 meals in a single 24-hour period.

9th January, 1946

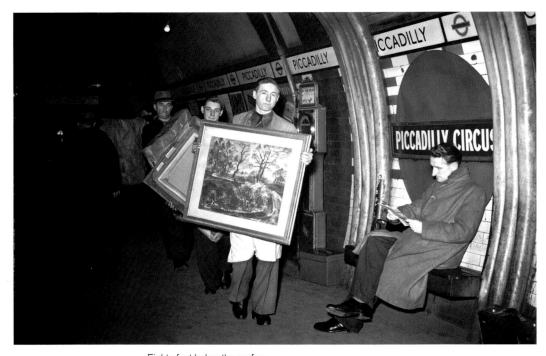

Eighty feet below the surface
of Piccadilly Circus is part
of the underground station
known as 'Aladdin's Cave'
where national art treasures
from the Tate gallery and the
London Museum were stored
at the outbreak of war. Here
the remaining 200 pictures are
taken from the underground
under police guard.
4th February, 1946

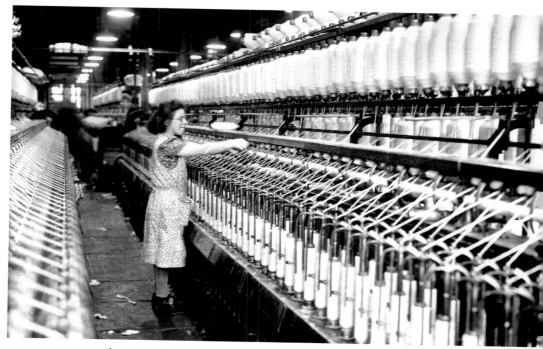

A woman working in Britain's waning cotton industry, as a postwar recruitment film sponsored by the Board of trade and Ministry of Labour, *Cotton Come Back*, directed by Donald Alexander, was released. Shot on location in the Lancashire towns of Shaw, Oldham and Rochdale, the film was designed to revivify trade and encourage workers back into the industry.
16th March, 1946

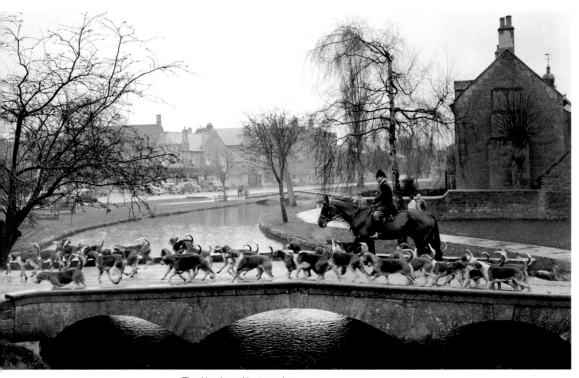

The Heythrop Hunt moving
through the Gloucestershire
village of Bourton-on-the-
Water on the way to meet at
Cold Aston.
26th March, 1946

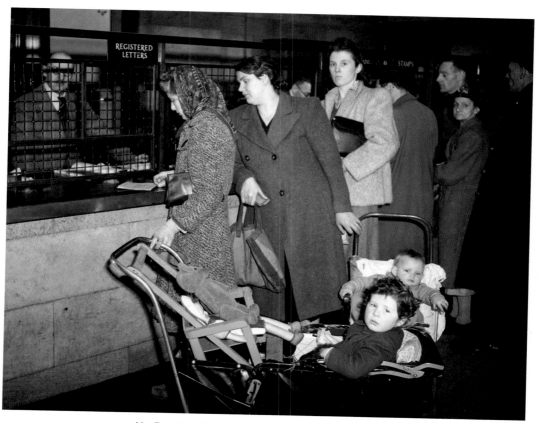

Mrs Ford (L), with her daughter, Ann drawing her Family
Allowance at Mount Pleasant Post Office, Clerkenwell,
London. The Family Allowances Act 1945 was an Act of
Parliament that came into operation from 6th August, 1946
and was the first law to provide child benefit in Britain.
1946

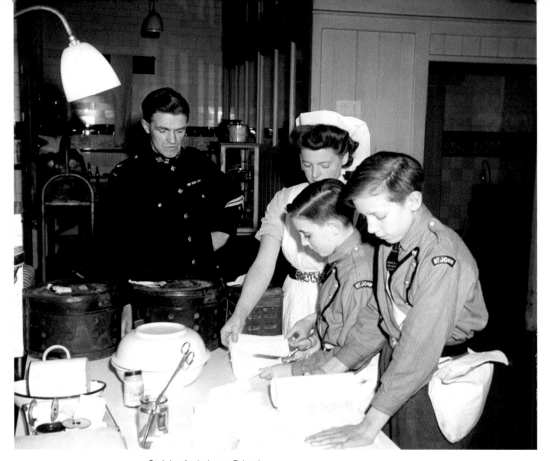

St John Ambulance Brigade cadets learn the practice of rolling bandages under the supervision of a nurse.
5th April, 1946

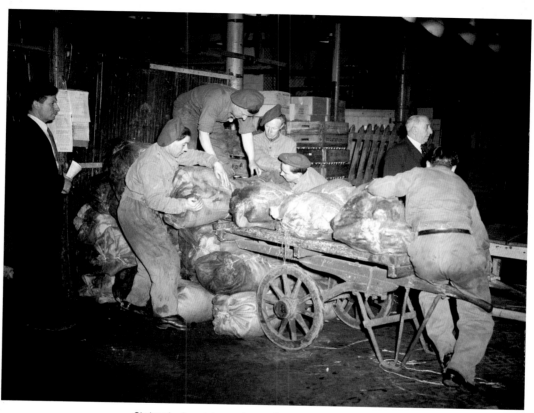

Six hundred provision workers at Smithfield Market came out on strike on 8th April, 1946 against an award by the Joint Industrial Council. One week later, three thousand meat porters struck in sympathy and members of the Pioneer Corps were sent into the market to maintain the supply of meat and prevent a loss of perishable commodities.
15th April, 1946

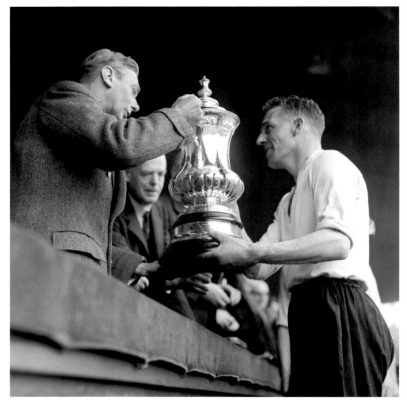

King George VI presents the FA Cup to Jack Nicholas, Derby County captain, after Derby won the match against Charlton Athletic 4–1 at Wembley Stadium. The Cup Final was the first since the start of the Second World War.
27th April, 1946

Facing page: Abyssinian troops arrive in London for the Victory Parade.
2nd May, 1946

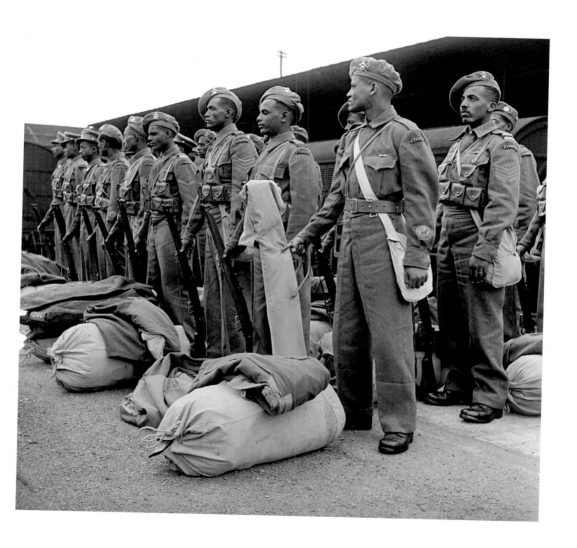

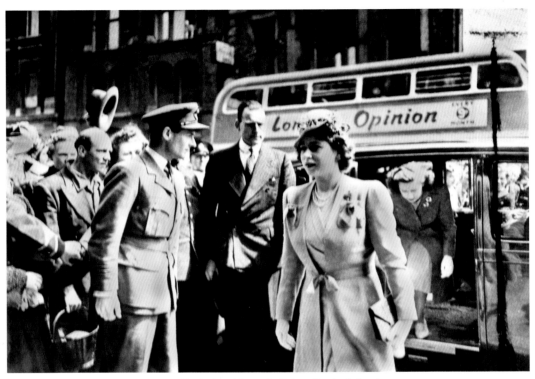

Princess Elizabeth arriving at the Palace Theatre in London to attend the all-star matinee of *1066 And All That*. Group Captain Peter Townsend (in uniform) looks on as Princess Margaret emerges from the car.

7th May, 1946

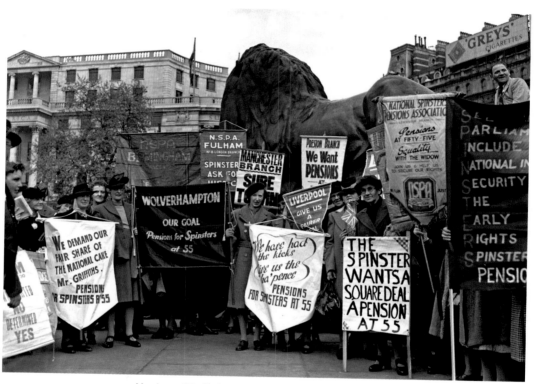

Members of the National Spinsters' Pensions Association, formed in 1935 by women textile workers in Bradford, hold a rally in Trafalgar Square, London demanding contributory pensions at 55.

12th May, 1946

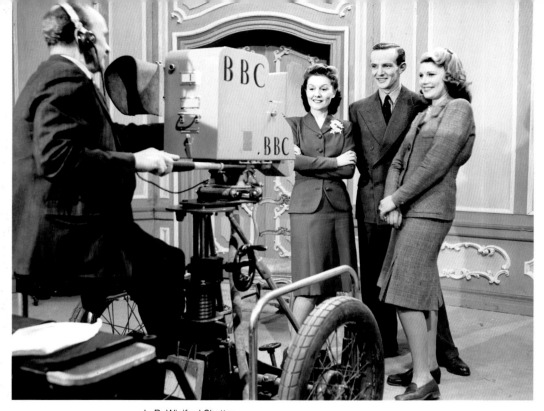

L–R: Winifred Shotter,
McDonald Hobley and
Jasmine Bligh during a
rehearsal at Alexandra
Palace for the return of
television following the
Second World War.
21st May, 1946

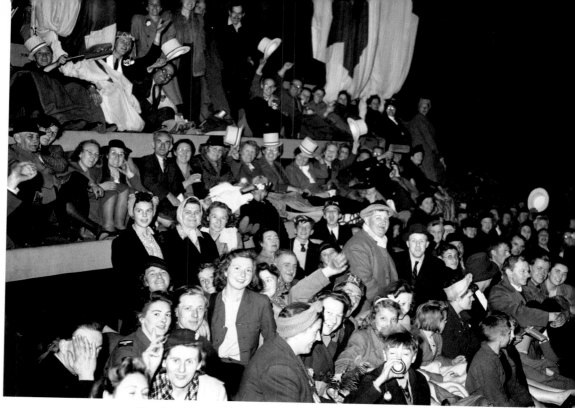

Crowds assembled in Trafalgar Square for a night-long vigil to see the Victory Parade.

7th June, 1946

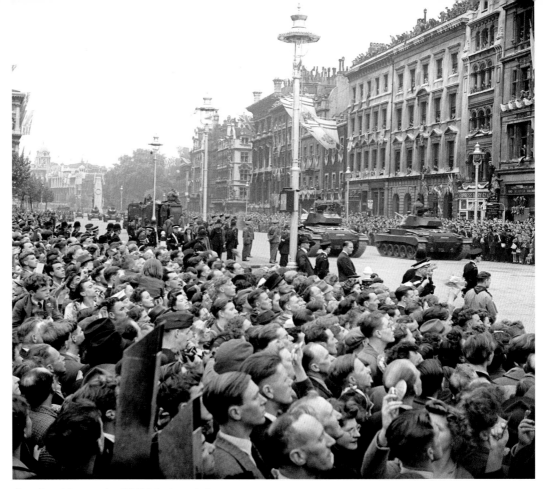

Crowds watch a parade of British tanks and other weapons
along Whitehall, London.
8th June, 1946

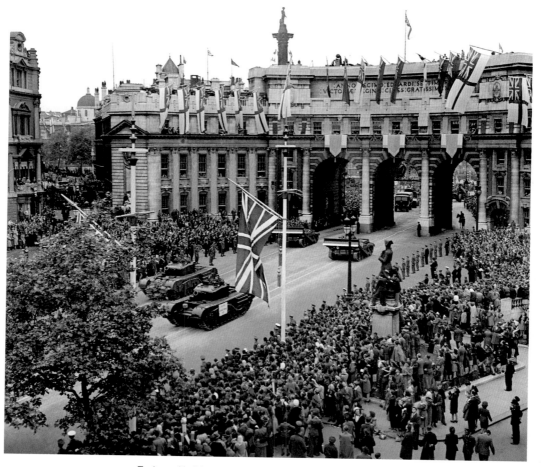

Tanks and bulldozers pass through Admiralty Arch and
head up The Mall towards Buckingham Palace, during the
Victory Parade.
8th June, 1946

Crowds pack the Oxford
Street pavements as the
Victory Parade makes its
way from Marble Arch.
8th June, 1946

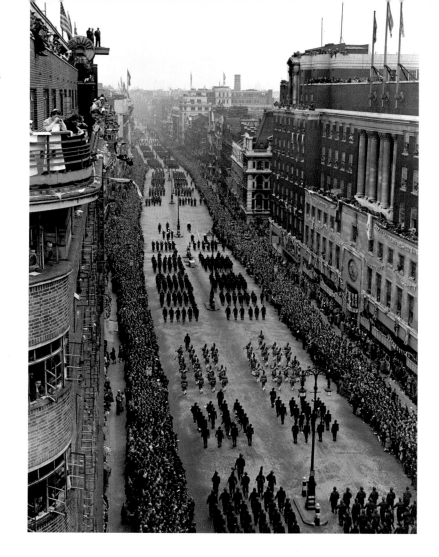

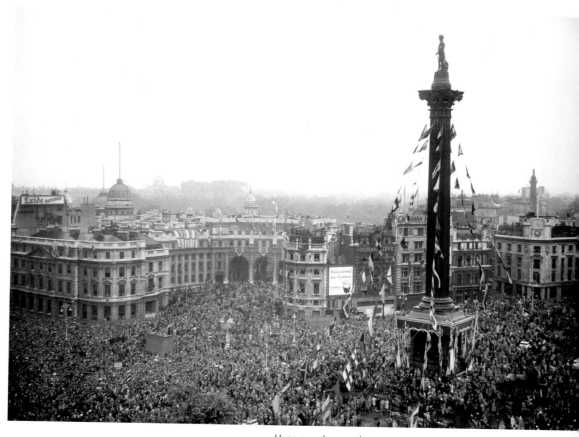

Huge crowds around
Nelson's Column watch the
Royal Air Force fly-over after
the Victory Parade.
8th June, 1946

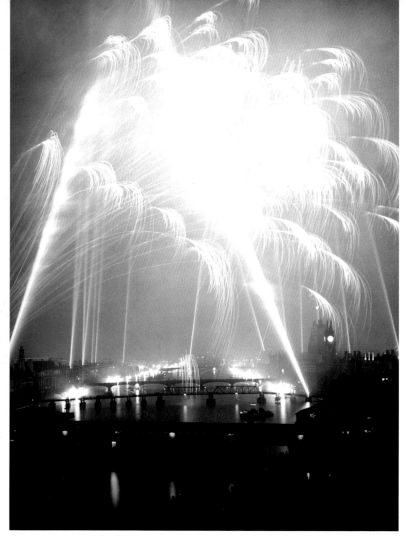

The scene from the roof of the Shell-Mex Building in London during the Victory Pageant on the Thames.
8th June, 1946

Facing page: A floodlit Buckingham Palace during Victory Day celebrations.
8th June, 1946

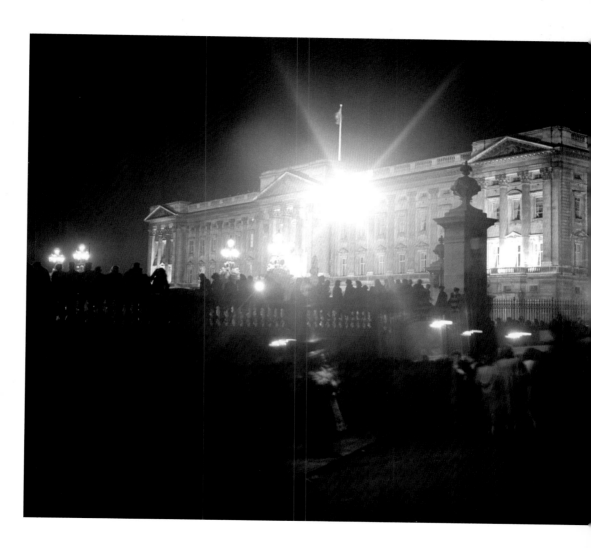

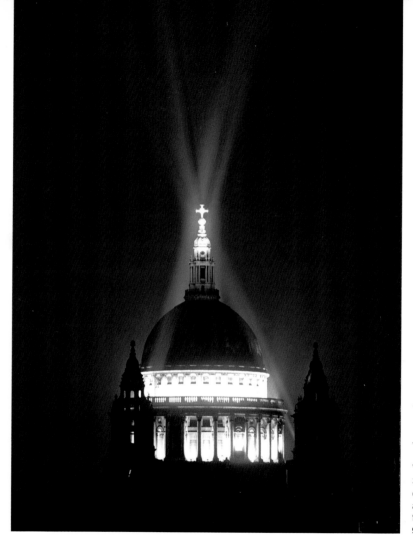

A floodlit St Paul's Cathedral on Victory Night.
8th June, 1946

Facing page: An aerial view of Southampton Docks with RMS *Queen Mary* at its centre. The ocean liner was the flagship of the Cunard Line from May 1936 until October 1946, when she was replaced by sister ship RMS *Queen Elizabeth*. With the outbreak of the Second World War, she was converted into a troop ship and ferried Allied soldiers for the duration of the war.
9th June, 1946

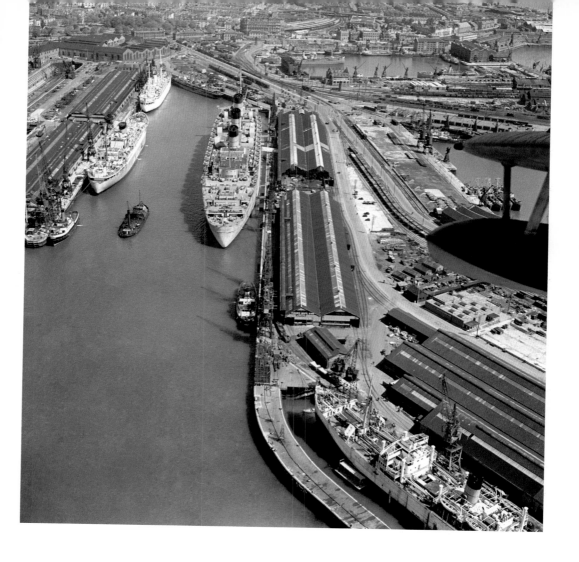

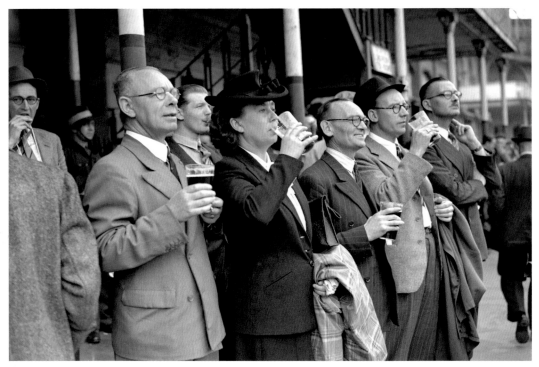

Spectators enjoy a pint while
watching England v India
play cricket at Lord's.
22nd June, 1946

Facing page: After
convalescence, war
disabled men who could
not return to active duty
helped in the war effort by
operating milling machinery,
and this work continued after
the end of hostilities.
28th June, 1946

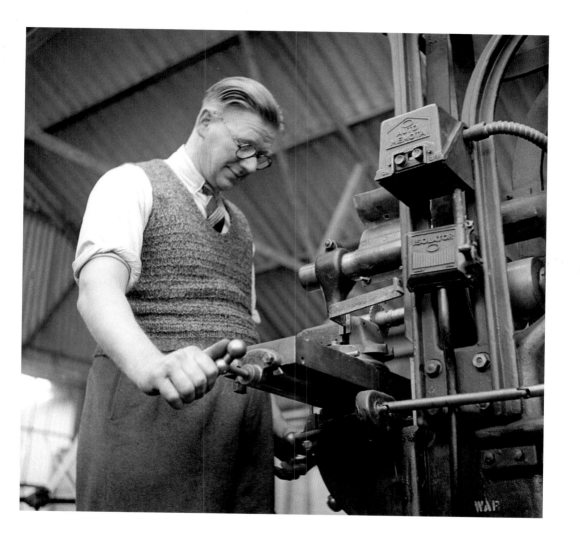

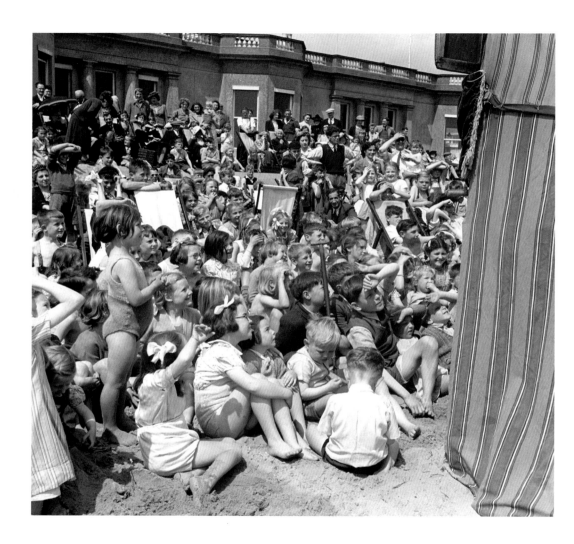

The operator of a prototype shutterless photo-finish camera waits for the runners to pass in front of him during testing. An actual race finish is to be used for the final test before the camera can be installed on racecourses throughout the country.
2nd July, 1946

Facing page: Children on the beach watching a Punch and Judy show.
1st July, 1946

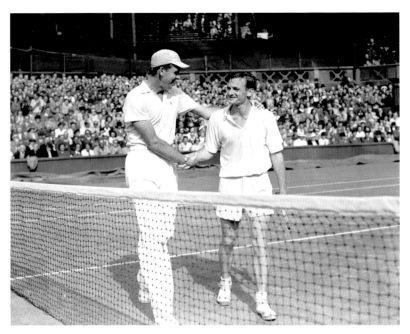

Australian Geoff Brown (R)
congratulates Vietman-born
Frenchman Yvon Petra on
winning the Wimbledon
men's singles tennis final in
five sets – the last man to
win the title wearing full-
length trousers.
5th July, 1946

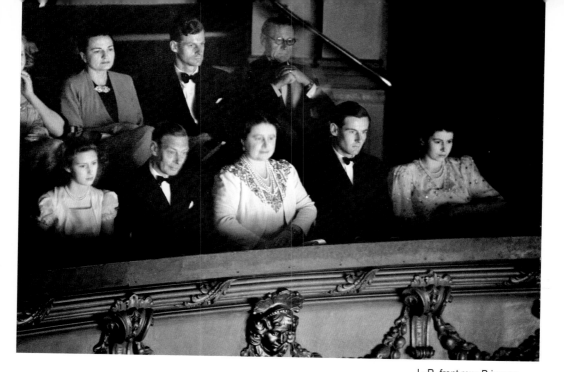

L–R, front row; Princess Margaret, King George VI, Queen Elizabeth, Group Captain Peter Townsend and Princess Elizabeth, in the Royal Box at the Strand Theatre in London.
5th August, 1946

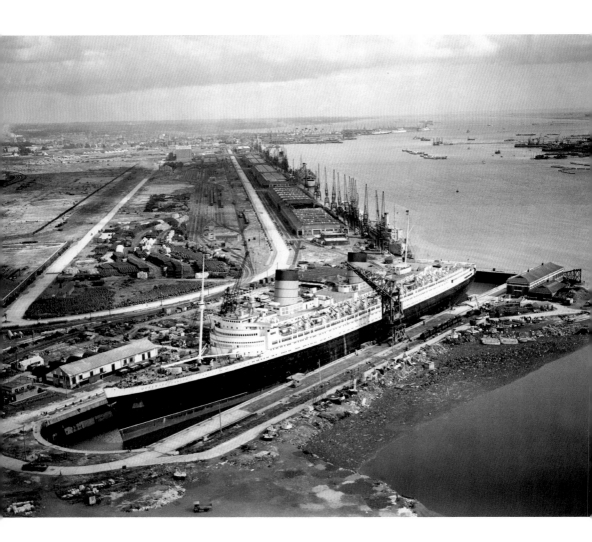

Facing page: The 83,000 ton RMS *Queen Elizabeth* occupies almost the entire area of the huge King George V Dock at Southampton. The enormous vessel is being re-fitted from its wartime role as a troop ship to its peacetime role as a luxury cruise ship.
7th August, 1946

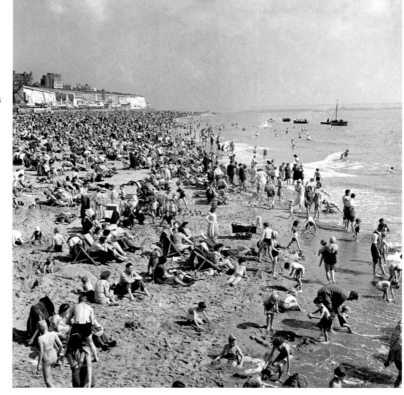

Crowds occupy the entire beach at Ramsgate, East Kent as the warm summer weather draws families to the popular seaside resort.
1st September, 1946

The kitchen of a modern cottage on display at the 'Britain Can Make It' exhibition at London's Victoria & Albert Museum. The exhibition of industrial and product design was organized by the Council of Industrial Design, later to become the Design Council. Press reports dubbed it 'Britain Can't Have It', since wartime austerity measures still in place meant that goods on display were intended for export.

23rd September, 1946

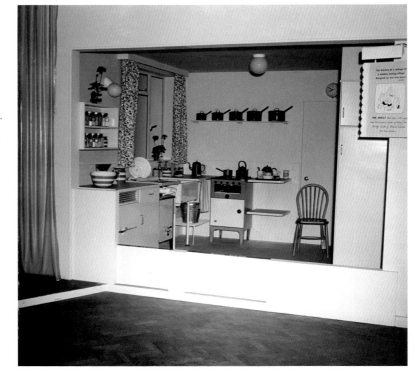

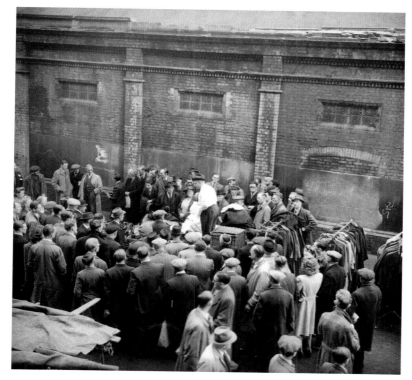

Petticoat Lane Market in East London had, from around 1600, become a commercial district where second-hand clothes and bric-a-brac were sold and exchanged. Although the market – which was not formally recognised until 1936 – occupied Wentworth Street and Middlesex Street, its former name had stuck. Jewish immigrants working the garment industry settled in the area in the 1880s but severe damage suffered to the area during the Blitz saw them begin to disperse. In the 1970s a new wave of immigration from India and east Asia would restore the area's vitality, centred around nearby Brick Lane.

1st October, 1946

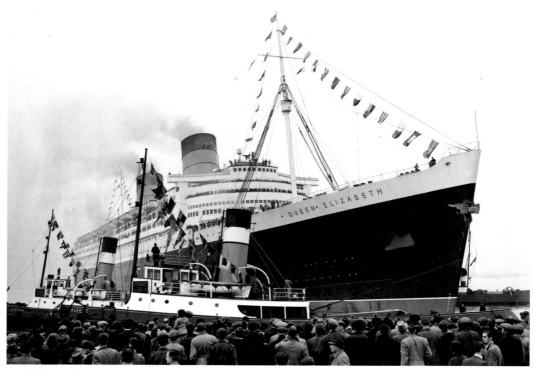

The 83,000 ton Cunard-
White Star Liner RMS
Queen Elizabeth casts
off from her moorings at
Southampton to begin her
maiden voyage to New York.
16th October, 1946

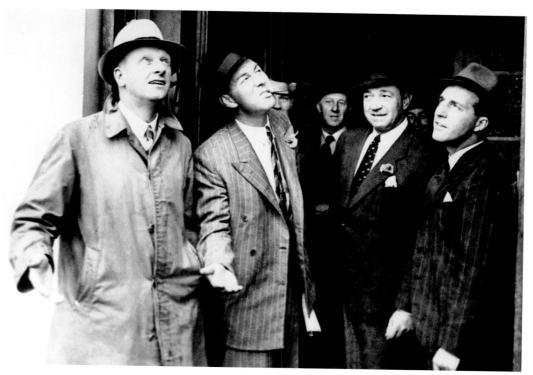

L–R: MCC's Major Howard (team manager), Norman Yardley, Wally Hammond and Bill Edrich check to see if the inclement weather has improved. No play was possible on the first day of the tour match – Australian XI v Marylebone Cricket Club – due to incessant rain.

8th November, 1946

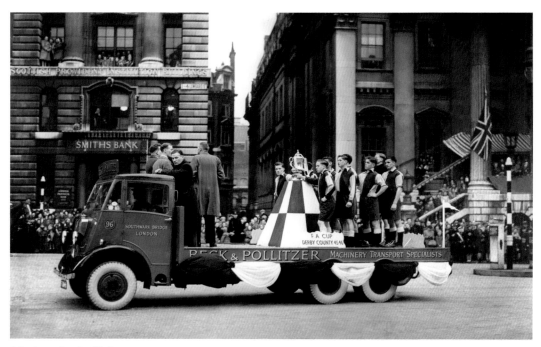

A float carrying the FA Cup,
and four of the Derby County
side who won the Cup, rolls
down Lombard Street, in the
City of London.

9th November, 1946

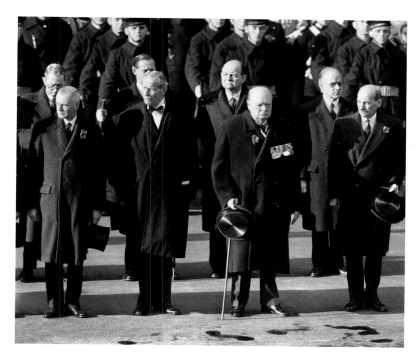

Prime Minister Clement Attlee (R), Winston Churchill (second R) and other members of the Cabinet observing the Two Minute Silence at the Cenotaph on Remembrance Day.
10th November, 1946

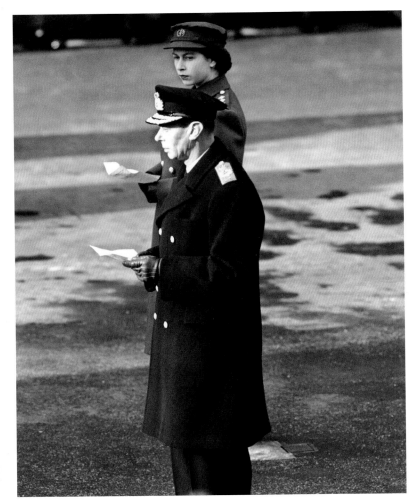

King George VI and
Princess Elizabeth during
the service at the Cenotaph
on Remembrance Sunday.
10th November, 1946

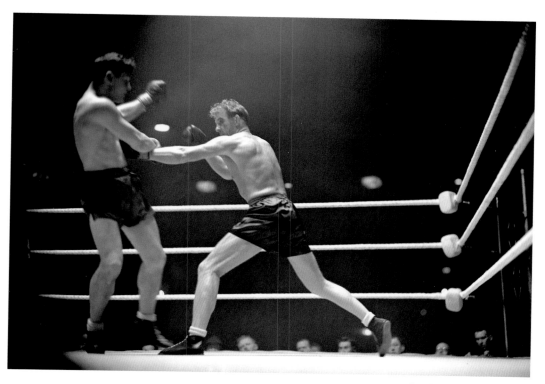

Sweden's Nils Andersson
goes on the attack against
Britain's Bruce Woodcock
in the British and Empire
heavyweight title fight,
which Woodcock would
win in three rounds after a
technical knock-out.
17th December, 1946

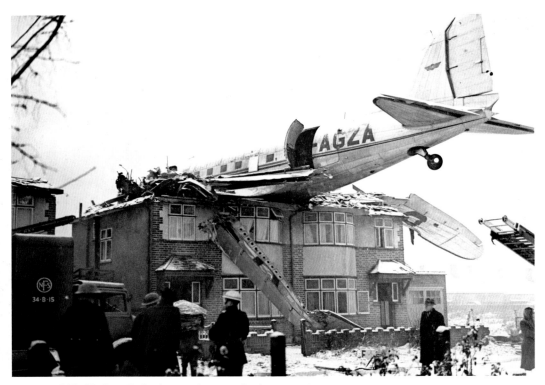

A Douglas DC3 of Railway Air Services perches precariously on top of a house in the London suburb of Northolt, Middlesex after crashing on to the roof. The aircraft had just taken off from RAF Northolt, where the captain, William Johnson, subsequently known as 'Rooftops', had supervised its de-icing prior to take-off. Fresh snowfall on the wings destroyed their lift, however, preventing it from climbing away. The crew of four and one passenger escaped unhurt.
19th December, 1946

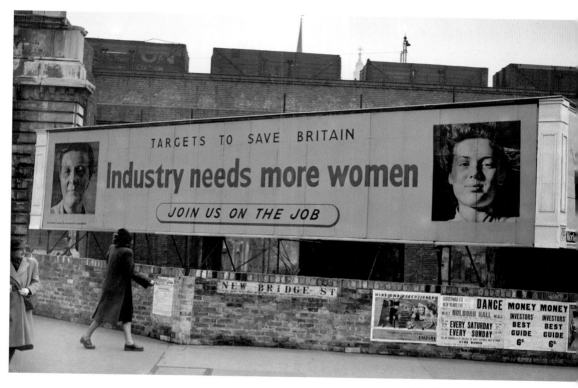

A bombed site in the heart of the City of London with a poster calling for women to help in industry.
1947

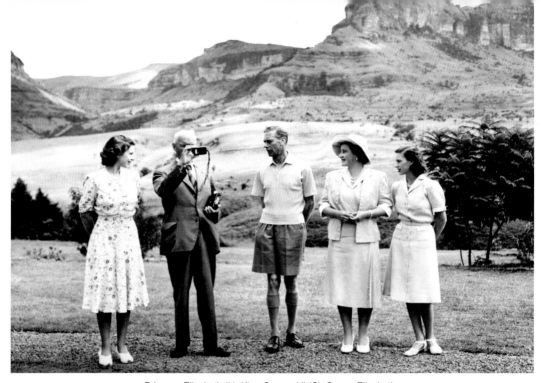

Princess Elizabeth (L), King George VI (C), Queen Elizabeth
(second R) and Princess Margaret (R) pose with Jan Smuts,
South African Prime Minister. Smuts had served in the First
World War and as a British field marshal in the Second
World War; he was a member of the Imperial War Cabinet
under Winston Churchill and was the only person to sign the
peace treaties ending both the First and Second World Wars.
1947

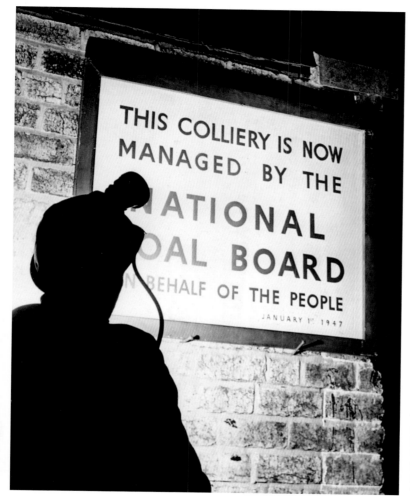

THIS COLLIERY IS NOW MANAGED BY THE NATIONAL COAL BOARD N BEHALF OF THE PEOPLE

JANUARY 1ST 1947

A sign highlighting the nationalisation of the coal industry. The Coal Industry Nationalisation Act of 1946 received Royal Assent on 12th July, 1946 and provided for the nationalisation of the entire British coal industry. It established the National Coal Board, which acted as the managing authority for coal mining activities.
1947

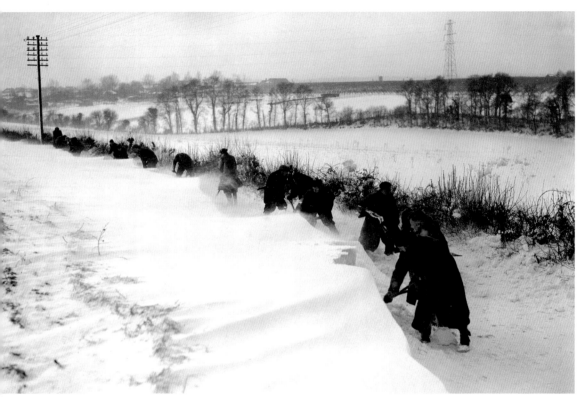

The winter of 1946–47 was particularly harsh throughout
Europe and Britain experienced several cold spells and large
drifts that blocked roads and railways. Here, men clear snow
that had drifted up to four feet high, blocking the Gravesend–
Meopham road in Kent.
1947

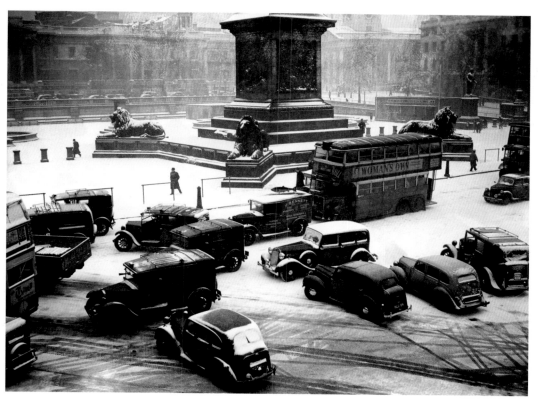

Traffic gingerly negotiates
Trafalgar Square after heavy
snowfall caused chaos on
the city's roads.
6th January, 1947

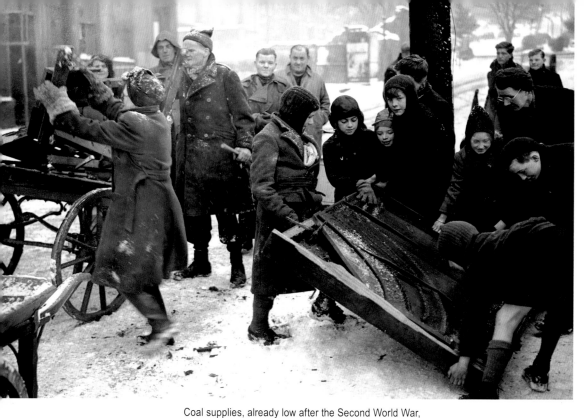

Coal supplies, already low after the Second World War, struggled to get through the severe weather conditions to power stations. Government measures to cut power consumption included restricting domestic electricity to 19 hours per day. Many people took matters into their own hands: Mr Mickleburgh, a Bristol piano merchant, gave away pianos to be chopped up for firewood.

31st January, 1947

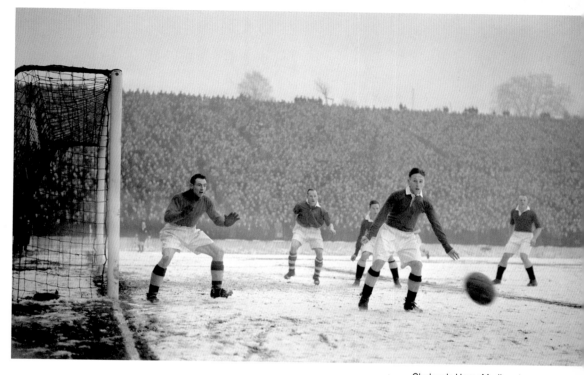

Chelsea's Harry Medhurst (L) and Dan Winter (R), and Charlton Athletic's Bill Robinson (C), wait for a cross to come in during a Division One match.
1st February, 1947

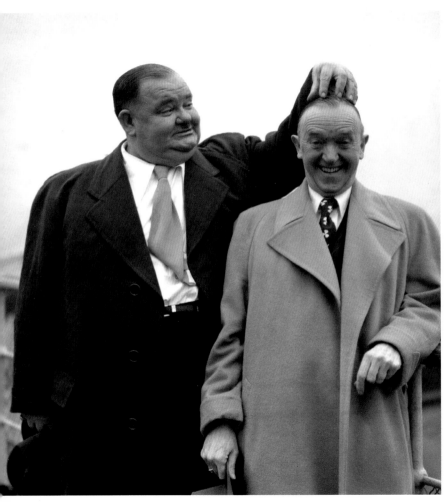

Oliver Hardy scratches the head of Stan Laurel, as the famous pair pose on board RMS *Queen Elizabeth* at Southampton, after sailing from New York. The slapstick comedy double act had made more than 100 films together, but from 1946 to 1950 embarked on a music hall tour of England, Ireland and Scotland.
10th February, 1947

Facing page: An ex-soldier trains to use the forge at The Rural Industries Bureau, established in 1921 by the Ministry of Agriculture and funded through the Development Commission, to develop rural industries. It produced booklets, reports and the quarterly magazine *Rural Industries*. In 1968 it merged with the Rural Industries Loan Fund to create the Council for Small Industries in Rural Areas (CoSIRA) and then with the Development Commission in 1988 as the Rural Development Commission.
2nd April, 1947

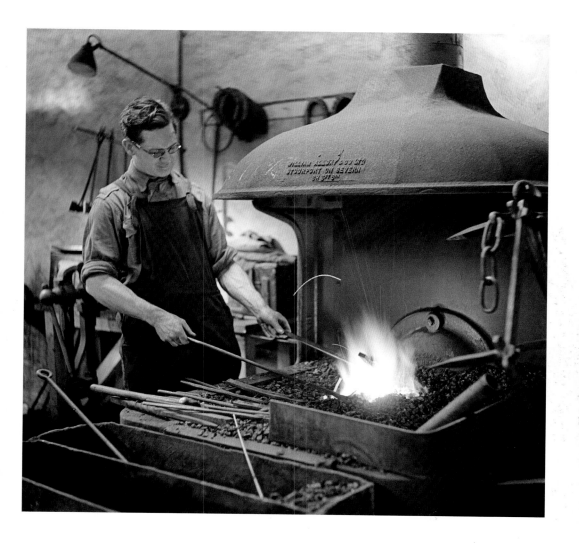

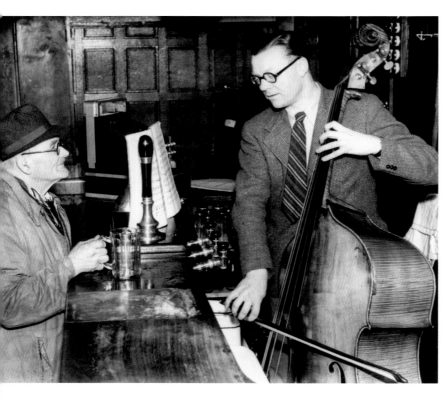

With his score propped against the beer pumps, Mr Victor Cook, landlord of the Park-lane Tavern, Cradley, near Wolverhampton, practises on his bull fiddle while a thirsty customer waits with an empty glass.
7th April, 1947

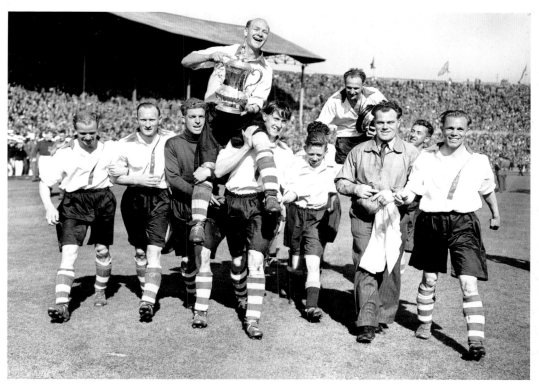

Charlton Athletic captain
Don Welsh, holding the FA
Cup, and winning goalscorer
Chris Duffy (R, background)
are chaired by their
teammates during the lap
of honour.
26th April, 1947

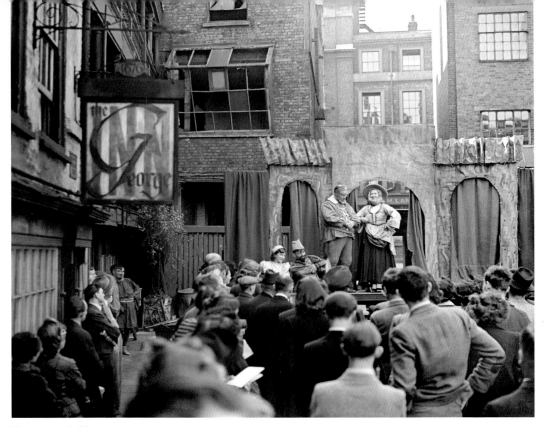

The courtyard of the
George Inn, Southwark,
where 300 years ago stood
Shakespeare's Globe
Theatre, was the scene of a
presentation in the traditional
Elizabethan manner of *The
Merry Wives of Windsor.*
26th April, 1947

The shop on the corner of Charlotte Street and Tottenham Court Road in London, where a motorcyclist was shot while trying to prevent the escape of three masked men carrying out a raid.

29th April, 1947

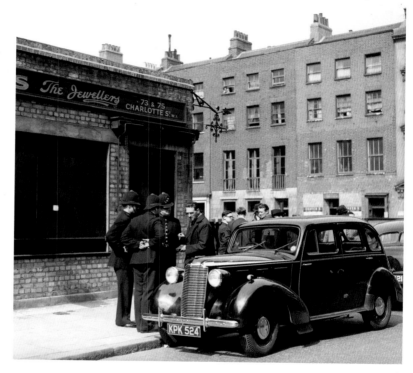

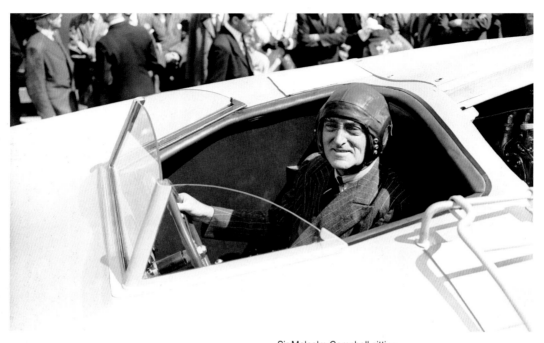

Sir Malcolm Campbell sitting
in the cockpit of *Bluebird*.
The English racing motorist
and motoring journalist
gained the world speed
record on land and on water
on numerous occasions
during the 1920s and 1930s.
1st May, 1947

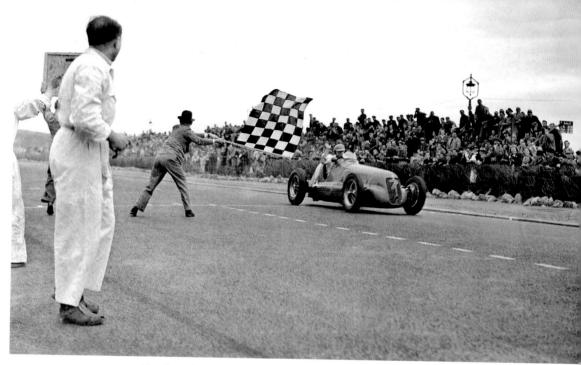

Reg Parnell, driving a
Maserati 4CL, raises his
hand in celebration as he
takes the chequered flag
in the Junior Car Club
(JCC) International Trophy
at Jersey.
8th May, 1947

The Duke and Duchess of Windsor in the grounds of Charters, described by *Country Life* as *"one of the last great country houses to be built in Britain"*. The property was frequented by royalty and personalities including as Winston Churchill and enjoyed high social status until 1959 when it was sold for use as a research and development facility first by Vickers and latterly by De Beers.

16th May, 1947

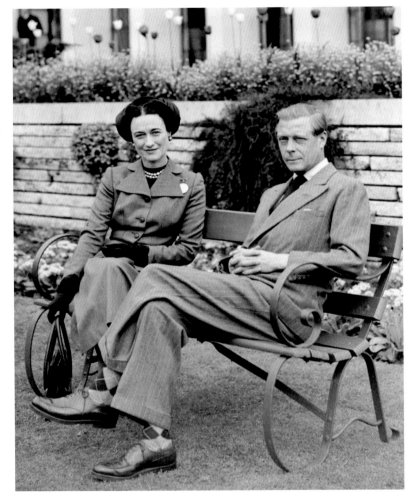

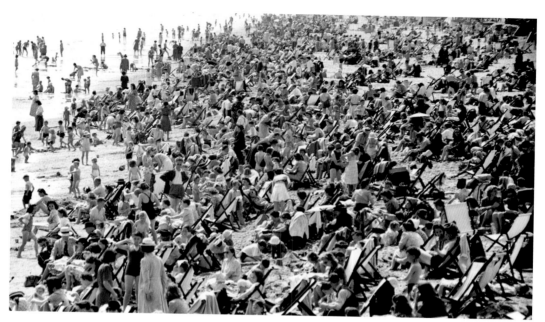

A crowded beach in Bournemouth, Dorset as temperatures soared. Between 30th May and 3rd June temperatures reached 31.7C or more in south-eastern England every day, the heatwave peaking at 34.4C in London.

31st May, 1947

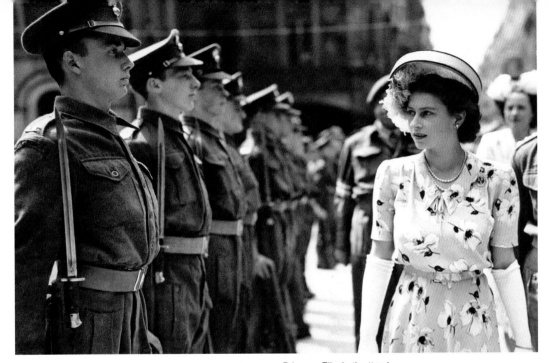

Princess Elizabeth attends
a ceremony to receive the
Freedom of the City of
London at Guildhall – the
first significant ceremony
that she undertook
unaccompanied.
11th June, 1947

Actor Laurence Olivier with
his wife Vivien Leigh, in their
London home.
11th June, 1947

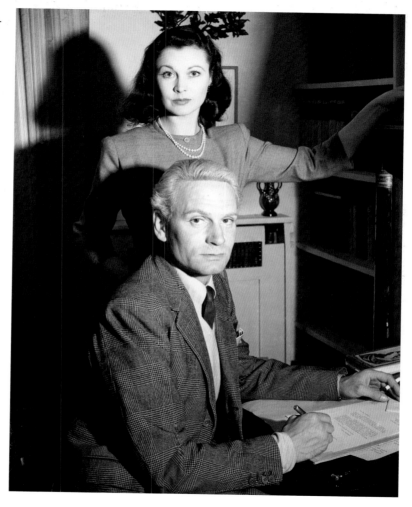

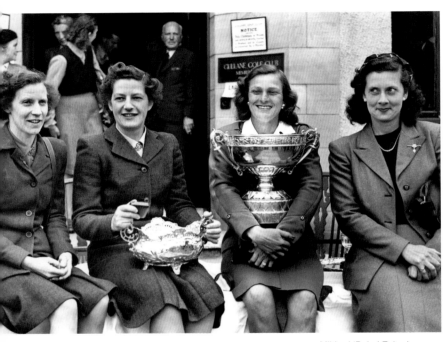

Mildred 'Babe' Zaharias (second R) holds on to the trophy as she poses with the runners up after winning the Ladies' Amateur Open Golf Championship.
12th June, 1947

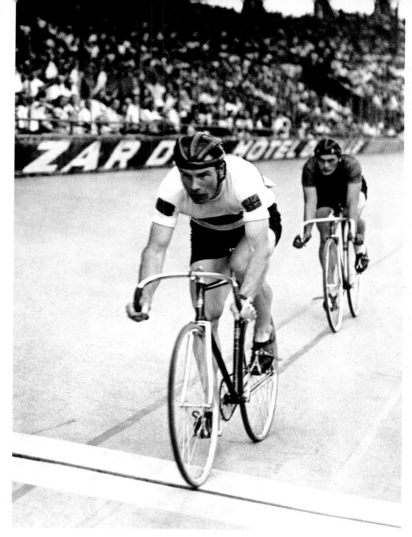

Great Britain's Reg Harris
crosses the line to win the
cycling World Amateur Sprint
Championship in Paris.
29th July, 1947

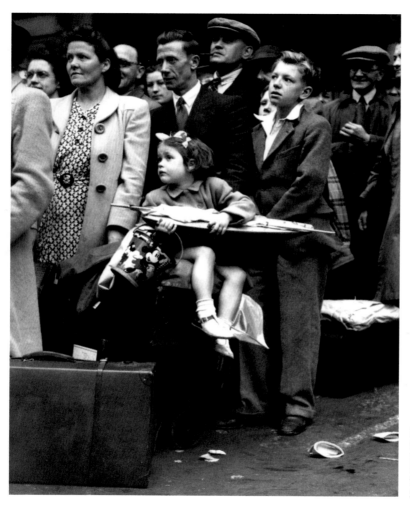

Holidaymakers queue for the Isle of Wight train at Waterloo Station, London hoping to escape the heat of the city for the cooler coast.
2nd August, 1947

Famous football
internationals (L–R)
Stanley Matthews, Stanley
Mortensen and George
Hardwick taking part in an
instructional film being made
by the Football Association
at Hendon.
17th September, 1947

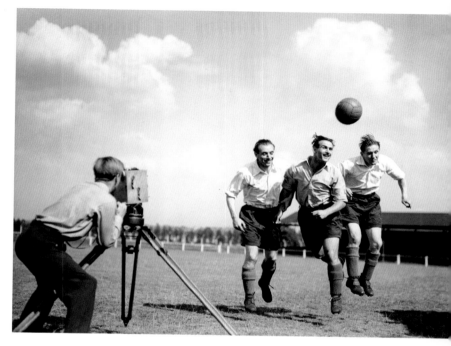

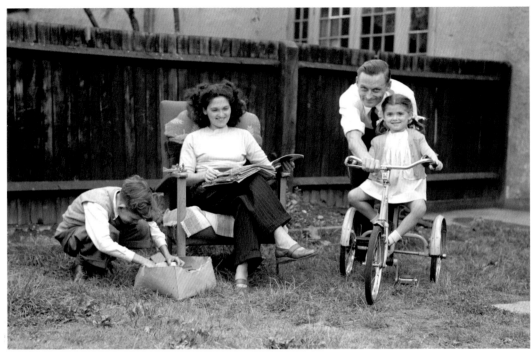

Mr Eustace Crick of Melrose Avenue, Cricklewood, London was adjudged 'One Hundred Per Cent Husband' as he won the prize in a local competition. Crick, pictured with his wife and children, Brian and Angela, neither smokes nor goes out at night but stays home to wash, cook and sew – and turns his weekly pay packet over to his wife intact.
21st September, 1947

England and Middlesex cricketer and Arsenal footballer Denis Compton is given a pre-match massage by trainer Jack Milne at Highbury Stadium in London.
23rd September, 1947

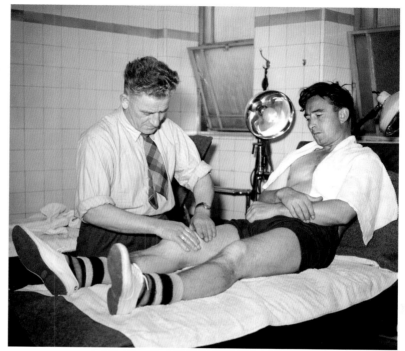

Norman Mighell, Deputy High Commissioner for Australia, and Mrs Mighell give 40 Dr Barnado's emigrants a send off from their Woodford Bridge home as they leave for the SS *Ormonde* at Tilbury. The boys are to go to a farming school in New South Wales, and the girls to a domestic service training home near Sydney. Although apparently happy at the prospect, many of the children who were forcibly 'exported' found that poor conditions and harsh treatment awaited them.

7th October, 1947

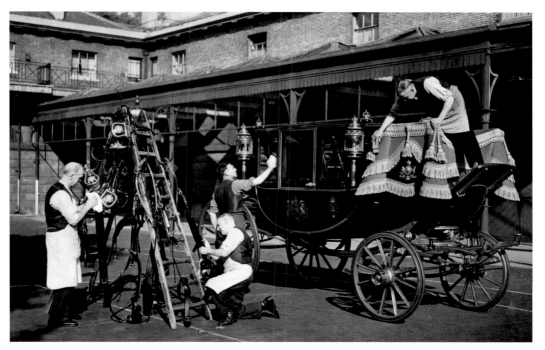

Members of the Royal Stables preparing The Glass Coach and the horses' harnesses for the forthcoming wedding of Princess Elizabeth to Philip Mountbatten on 20th November. The fine carriage, built by Peters & Sons of London in 1910, would be used to convey the bride-to-be to Westminster Abbey before the service.

9th October, 1947

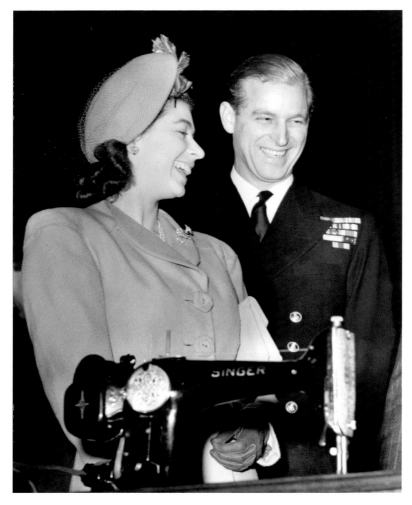

Princess Elizabeth and Lieutenant Philip Mountbatten, at Clydebank for the launching of the liner RMS *Caronia*, stopped at the Town Hall to receive the town's wedding present – an electric sewing machine.
31st October, 1947

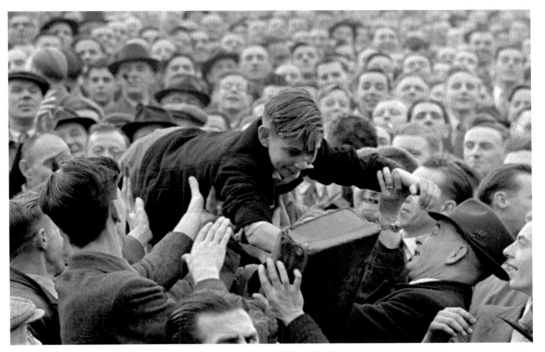

At Stamford Bridge, a
young fan is passed over
the heads of the crowd to
a better viewing position at
the front of the terrace for
the match between Chelsea
and Arsenal.
1st November, 1947

John Shire and Ian Berry
are studying an Official
Souvenir Programme of the
forthcoming Royal Wedding
as they prepare to sell them
along the procession route.
10th November, 1947

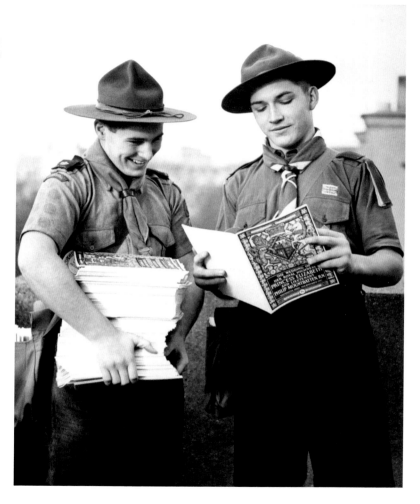

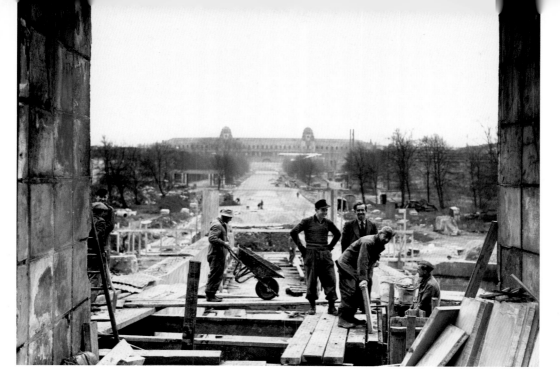

Workmen involved in the construction of a new road that will lead to Wembley Stadium in preparation for the following year's Summer Olympic Games.
11th November, 1947

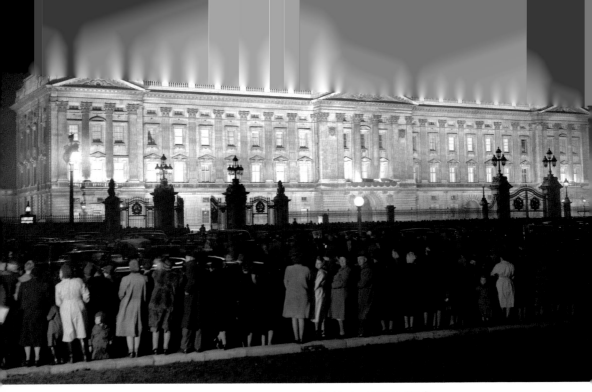

Buckingham Palace stands
bathed in light against the
night sky as people in their
hundreds surge to the
railings to see Princess
Elizabeth and her fiancé on
the eve of their wedding.
19th November, 1947

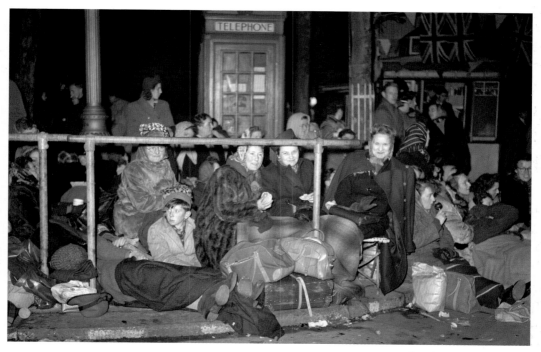

Crowds camped out
overnight on the streets of
London to assure them of
a clear view of the Royal
couple on their wedding day.
20th November, 1947

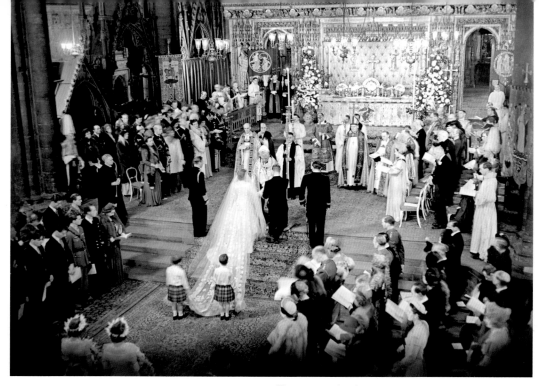

The scene at the altar steps during the Royal Wedding ceremony in Westminster Abbey. King George VI stands to the left of the bride. On the bridegroom's right is the groomsman, the Marquess of Milford Haven. The bride's train is held by two pages, Prince William of Gloucester and Prince Michael of Kent.
20th November, 1947

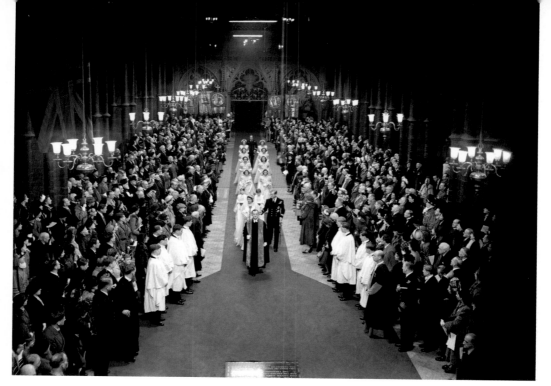

Princess Elizabeth and
Prince Philip walk down
the aisle to the west door
of Westminster Abbey after
their wedding, followed by
their two pages and eight
bridesmaids.
20th November, 1947

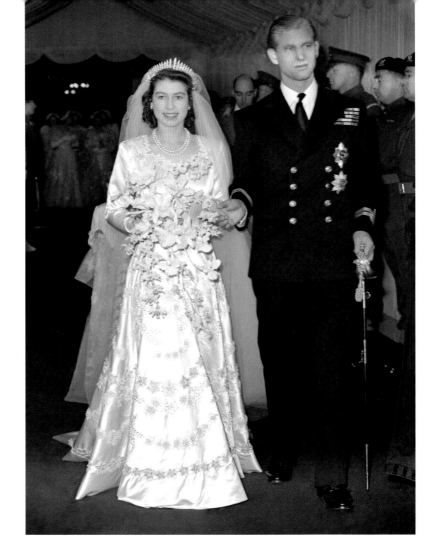

Princess Elizabeth
and Prince Philip leave
Westminster Abbey after
their marriage ceremony.
20th November, 1947

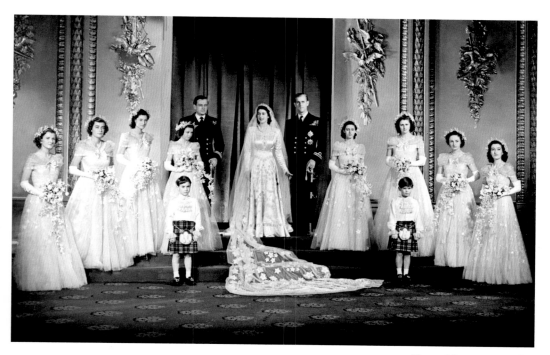

The wedding group pose for photographs in the Throne Room at Buckingham Palace after the wedding.
20th November, 1947

Princess Elizabeth enjoys
a stroll with her husband,
The Duke of Edinburgh.
23rd November, 1947

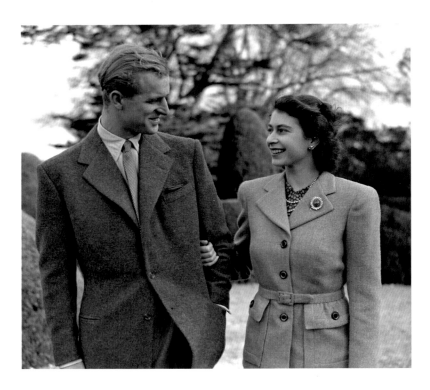

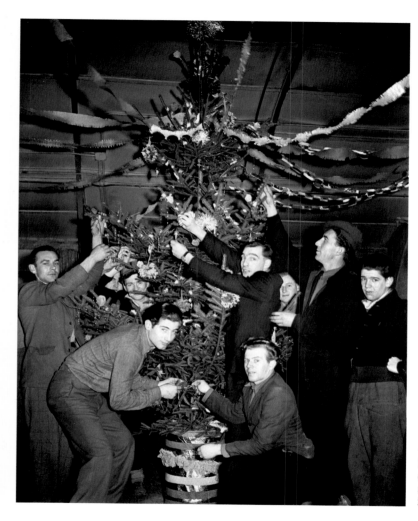

Trainee coal miners enter
into the Yuletide spirit by
decorating a Christmas tree
at their hostel.
22nd December, 1947

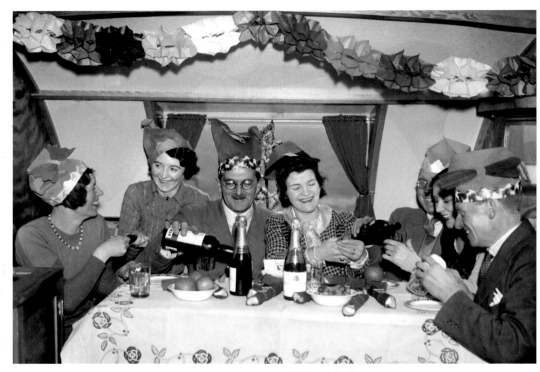

Members of the Caravan
Club enjoy their Christmas
dinner – and a little of the
Christmas spirit – in their
home on wheels.
22nd December, 1947

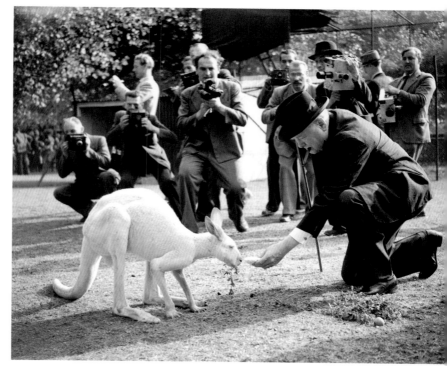

Winston Churchill visits Digger, a white kangaroo, at London Zoo. The only albino kangaroo in Europe, Digger had been presented to Churchill by the Australian Stockbreeders Association.
3rd January, 1948

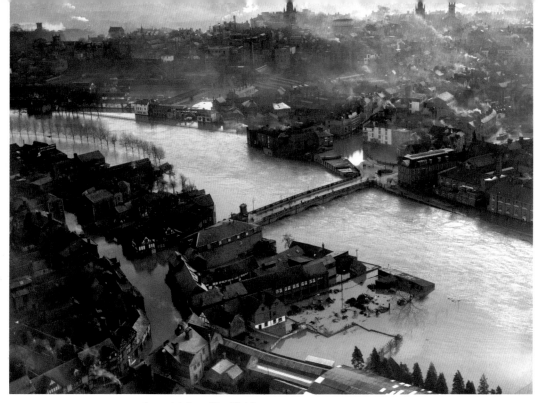

An aerial view of the Welsh
Bridge area of Shrewsbury
after serious flooding of the
Severn and Wye rivers.
16th January, 1948

Boxing trainer Nat Seller tapes Freddie Mills' hands before a sparring session. Boxers' hands are taped tightly for protection, to lessen the risk of their bones bowing out from a punch and breaking. The 'boxing fracture' – a tiny break on the fleshy part of the little finger – is a common injury
20th January, 1948

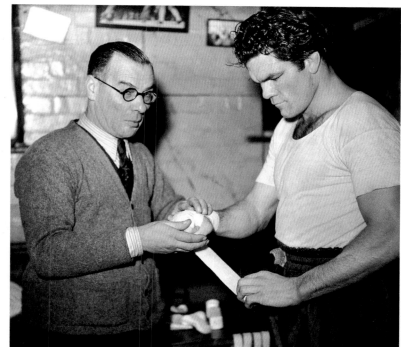

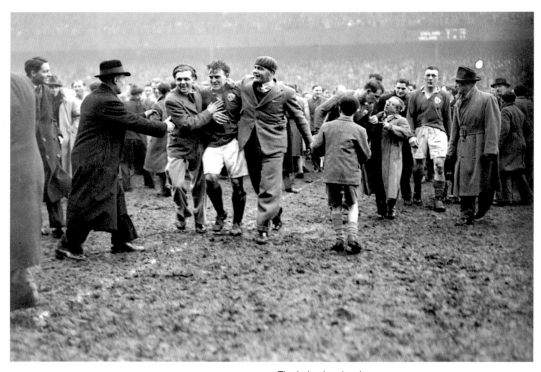

The Ireland rugby players
are mobbed by jubilant fans
at the final whistle, after they
held off England 11–10 in the
Five Nations Championship.
14th February, 1948

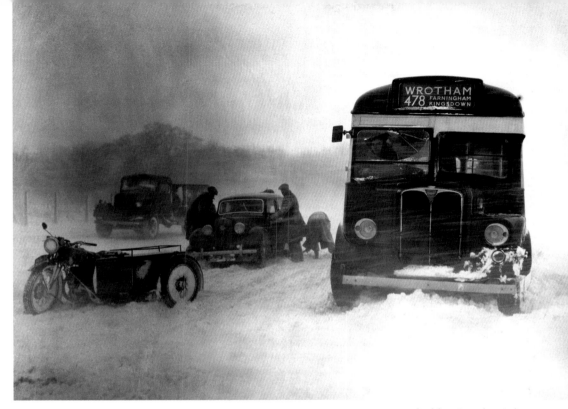

An AA motorcycle patrolman renders assistance as a bus and several cars struggle through a snowstorm between London and Maidstone, Kent.
21st February, 1948

Surprise winner of the Chelteham Gold Cup, Cottage Rake (C), with jockey Aubrey Brabazon in the saddle, is led in by owner Frank Vickerman after victory. The young bay had failed his first three veterinary examinations, was considered to be too short winded to be a competitive racehorse, and that arthritis would make any racing career short-lived. However, he went on the win the Gold Cup in 1949 and 1950, and continued to race until he was 15.

4th March, 1948

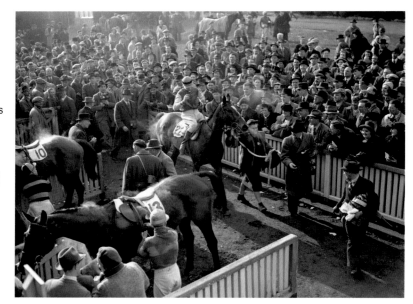

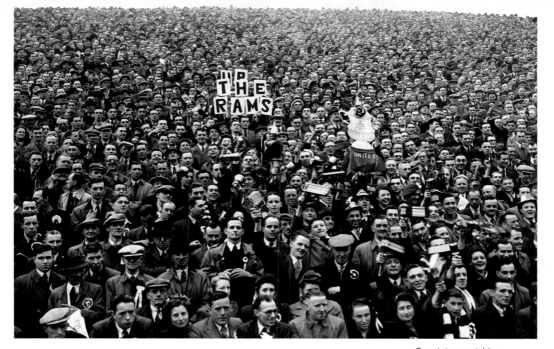

Spectators watching
the FA Cup semi final
between Manchester
United and Derby County
at Hillsborough Stadium,
Sheffield. United won 3–1
with Stan Pearson scoring
each goal.
13th March, 1948

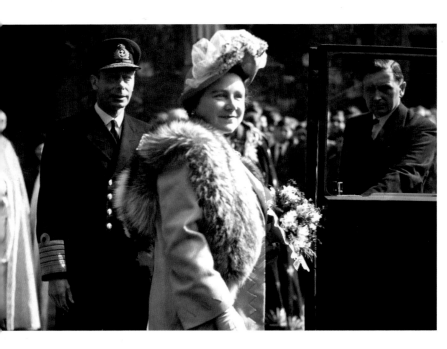

King George VI and Queen Elizabeth at Westminster Abbey Maundy Service.
25th March, 1948

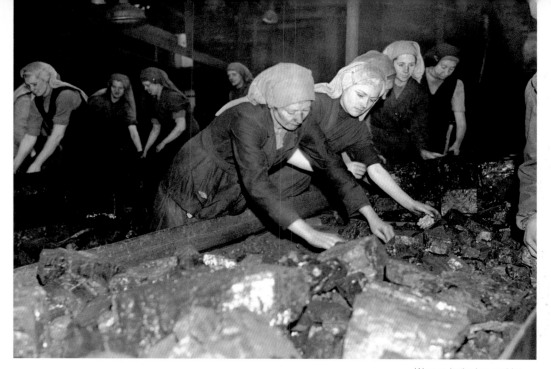

Women in the Lancashire coalfields screening stone, shale and rubbish from the coal by hand as it passes along a conveyor belt from the pithead to awaiting railway wagons.
30th March, 1948

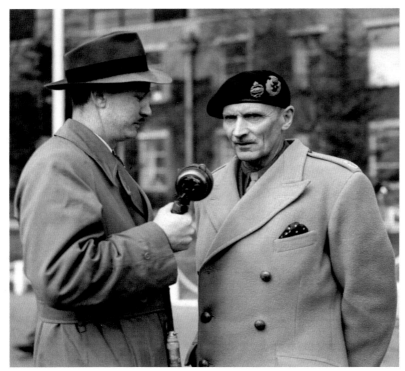

Field Marshal Viscount Montgomery of Alamein, one of the British army commanders of the Second World War, has a word for the BBC after his arrival at Northolt from Berlin. He went to the German capital for talks with Soviet Military Governor Marshal Sokolovsky regarding the tension existing between the allied forces there.

7th April, 1948

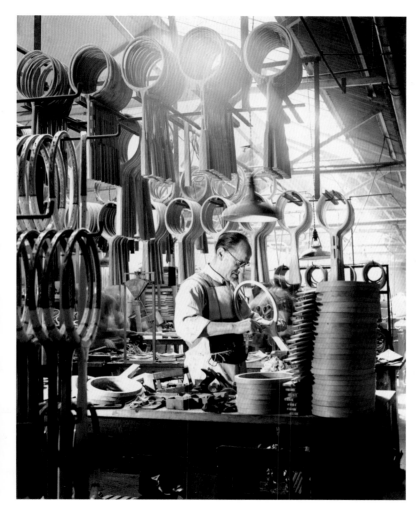

Craftsman F. Boswell shapes
the bows of tennis racquets
at the London factory of
Lillywhite, Frowd and Co.
15th April, 1948

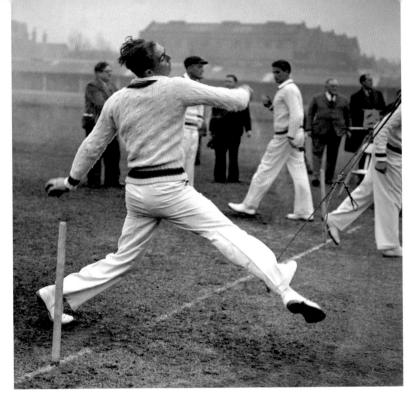

Australia's Bill Johnston
bowling at a practice
session during Australia's
tour of England.
17th April, 1948

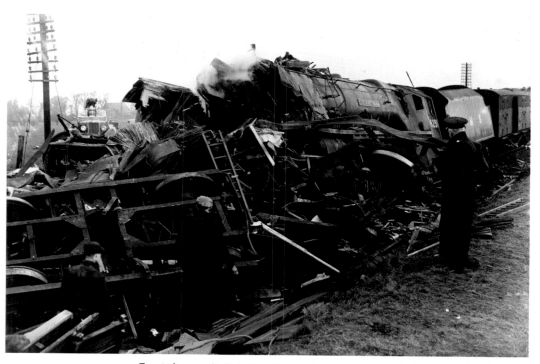

Twenty-four people died after a Glasgow to London Euston train stopped near Winsford, Cheshire, when the communication cord was pulled by a passenger, a soldier on leave seen to depart the train after it had stopped. A following postal express hauled by the LMS Coronation Class *City of Nottingham* ran into the train, leaving only five of the ten passenger coaches and eight of the 13 postal coaches intact. The signalman at Winsford Station had erroneously reported the passenger train clear before accepting the postal train.
17th April, 1948

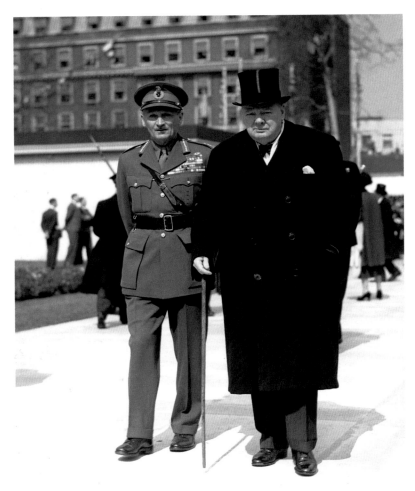

Winston Churchill and
Field Marshal Viscount
Montgomery leaving after the
unveiling ceremony of the
statue of former US President
Franklin D. Roosevelt,
sculpted by Sir William Reid
Dick, in Grosvenor Square,
London, the traditional home
of the American presence in
the city.
18th April, 1948

Manchester United's Jack Rowley (R) climbs high to power a header goal-ward in the FA Cup Final against Blackpool. United won the match 4–2 with two goals by Rowley, and one each by Stan Pearson and John Anderson.

24th April, 1948

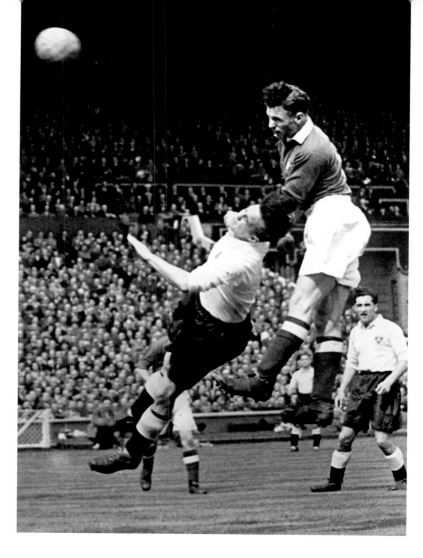

Manchester United captain Johnny Carey is carried on the shoulders of his teammates, after they won the FA Cup final against Blackpool.
24th April, 1948

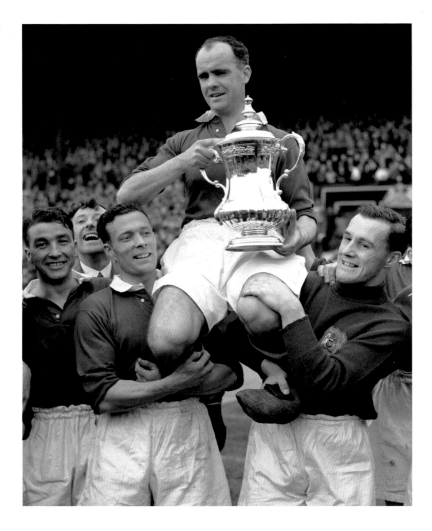

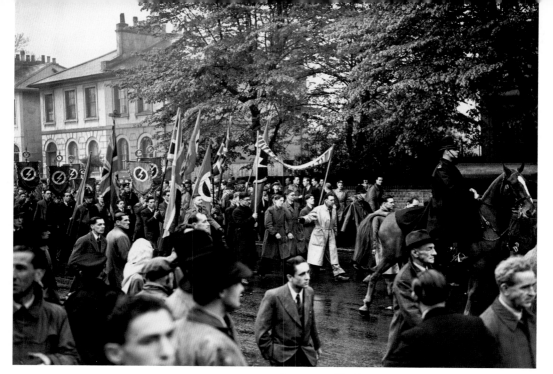

Supporters of Sir Oswald Mosley's British Union of Fascists held an open air May Day meeting. The BUF had been banned by the government in May 1940 and Mosley, along with 740 other fascists, was interned for much of the Second World War. After the war, Mosley attempted to revive his brand of fascism in the Union Movement, although by the summer of 1948 attendance at rallies had fallen. Mosley left Britain in 1951 to live in Ireland, and later moved to Paris, saying *"You don't clear up a dungheap from underneath it."*
1st May, 1948

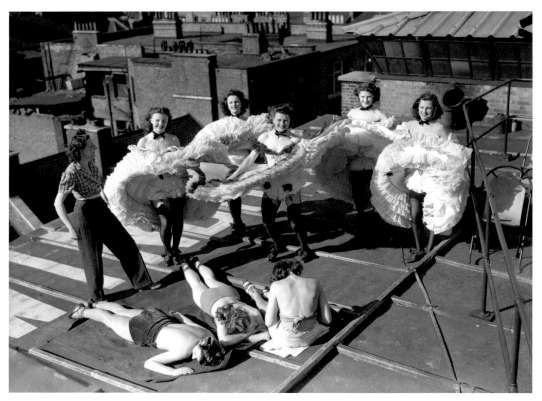

London's Windmill Theatre was a playhouse and variety theatre famous for its nude revues and risqué fan dance. Its motto "We Never Closed" referred to the fact that it remained open, apart from compulsory closure for 12 days in 1939, throughout the Second World War, even at the height of the Blitz. Here 'Windmill Girls' take the opportunity of fine spring weather to practice the 'Can-can' on a rooftop.
15th May, 1948

Children playing in the sand at Butlin's Holiday Camp in Skegness. This was the first of Billy Butlin's holiday camps, which opened in 1936. It was taken over for military use in 1939, and was known as HMS *Royal Arthur*. The camp reopened to holidaymakers after the Second World War in 1946.
1st June, 1948

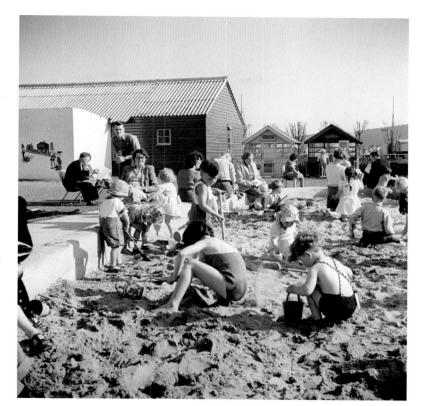

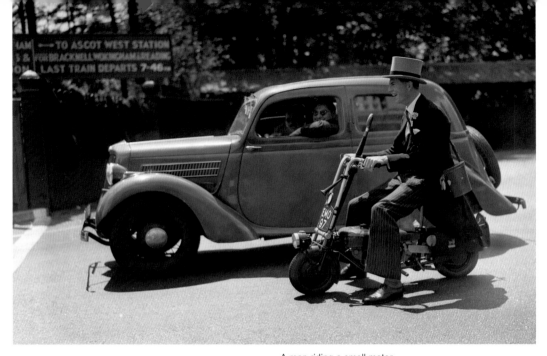

A man riding a small motor
scooter – of a type used
by airborne troops during
the Second World War
– at Ascot Racecourse
is nevertheless correctly
dressed for the occasion.
5th June, 1948

Horse racing was not the only activity at Royal Ascot. Here a woman has her palm read, possibly hoping for a clue that her chosen horse might win!
5th June, 1948

Jamaican immigrants are met by RAF officers after the troopship *Empire Windrush* lands them at Tilbury. During the Second World War, many men and women from the Caribbean had joined Britain's armed forces and in 1948 a number were on home leave. Some returned to rejoin the RAF, while they were joined by other Jamaicans who seized the chance to see Britain. The arrival of the migrants was the beginning of the multi-racial society we know today. **22nd June, 1948**

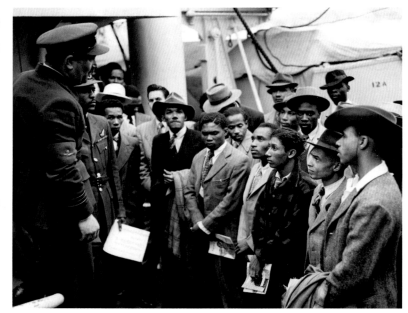

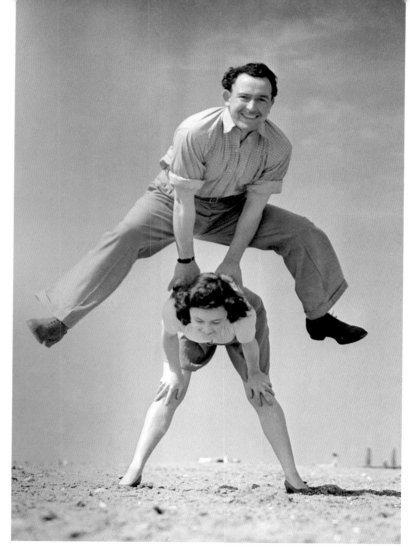

Innocent fun on the beach at Skegness. Nearly 60 years later Butlin's would offer couples the chance to be married at the resort with an optional *Viva Las Vegas* package, complete with Elvis impersonator.
1st July, 1948

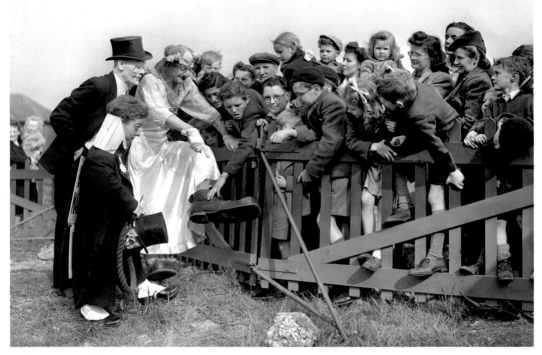

Performers entertain local children at the Bertram Mills
Circus. Founder Bertram W. Mills (1873–1938) had
inaugurated a touring circus in Britain, which became unique
among British circuses, always appearing at London's
Olympia for the Christmas season, and remained popular
until the 1960s.
1st July, 1948

American ventriloquist Edgar Bergen with his lifelong sidekick Charlie McCarthy (L) and Mortimer Snerd performing at the Savoy Hotel, London. Surprisingly, Bergen's real success was on radio: the popularity of a ventriloquist on radio, when one could see neither the dummies nor his skill, surprised and puzzled many critics, then and now.

1st July, 1948

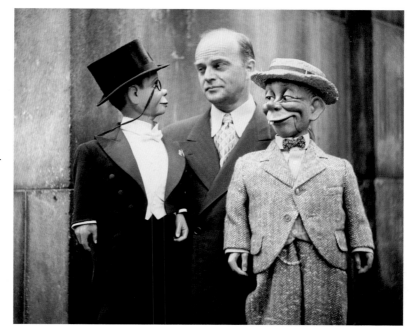

Golf Open champion Henry Cotton makes his acceptance
speech after collecting the Claret Jug. He achieved fame
during the 1930s and 1940s, with three victories in The Open
Championship in 1934, 1937 and 1948. During the Second
World War Cotton served with the Royal Air Force, raising
money for the Red Cross by playing exhibition matches, for
which he was awarded an MBE.

2nd July, 1948

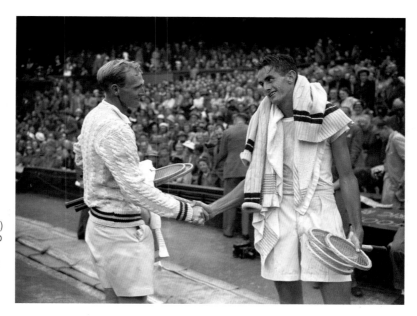

American John Bromwich (L) congratulates Australian Bob Falkenburg on winning the men's singles championship at Wimbledon in five sets (7-5 0-6 6-2 3-6 7-5).

2nd July, 1948

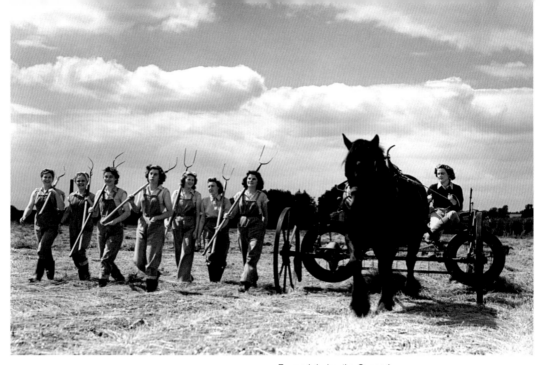

Formed during the Second
World War, the Women's
Land Army continued
to provide agricultural
workers to help on the land
until disbanded in 1950.
Here, trainees armed with
pitchforks set out to turn hay
in preparation for stacking.
9th July, 1948

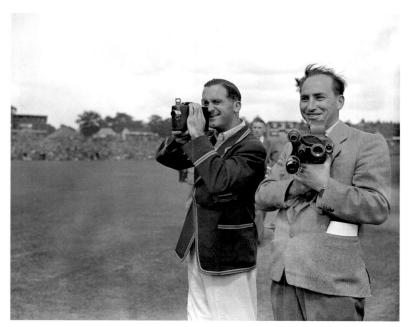

Cricket in motion. England's Godfrey Evans (L) films the Australian players with a cine camera as they take to the field for the Fourth Test Match, which started at Headingley, Leeds on 22nd July 1948.

22nd July, 1948

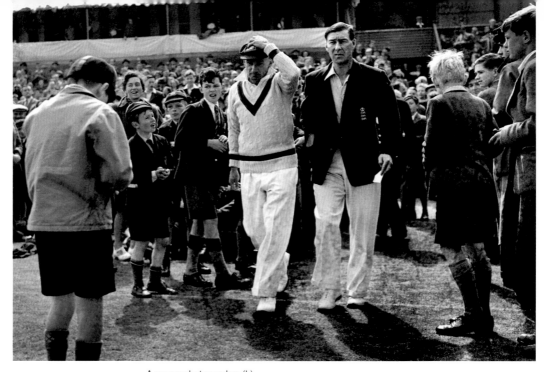

A young photographer (L) snaps a picture of Australia's Don Bradman (C) and England's bowler Norman Yardley (R) as they emerge from the pavilion onto the cricket pitch at the start of the Fourth Test Match at Headingley.

22nd July, 1948

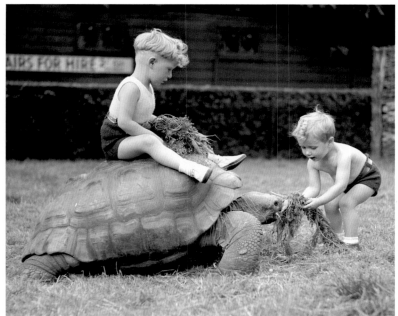

Young Michael Setford, sitting on George, the 60-year-old tortoise, and his cousin Michael Smith try to entice the Galapágos giant into a slow gallop at London's Regents Park Zoo.
26th July, 1948

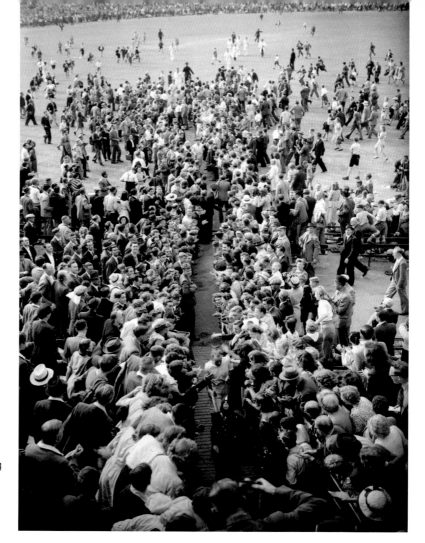

Australia's Don Bradman makes his way back to the pavilion through crowds of well-wishers after helping his team to victory with an unbeaten 173 on the final day of the Ashes Fourth Test.

27th July, 1948

England captain Norman Yardley (R) congratulates his opposite number, Australia's Don Bradman (L), on his unbeaten 173, which helped Australia set a new Test record by scoring 404 in their second innings to win the game.

27th July, 1948

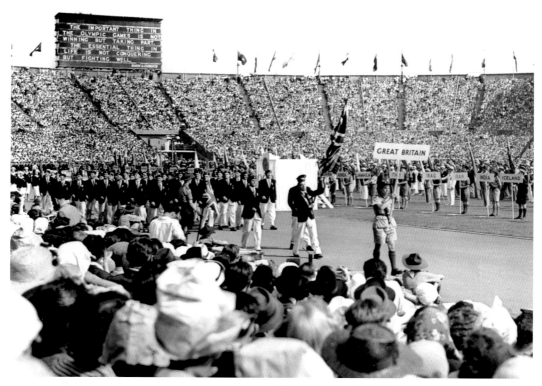

The British team at Wembley
Stadium during the opening
ceremony of the 1948
Olympic Games.
29th July, 1948

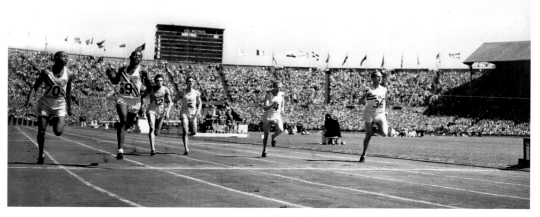

USA's Harrison Dillard
(second L) breaks the tape
to win the men's 100m
semi final at the London
Olympic Games.
30th July, 1948

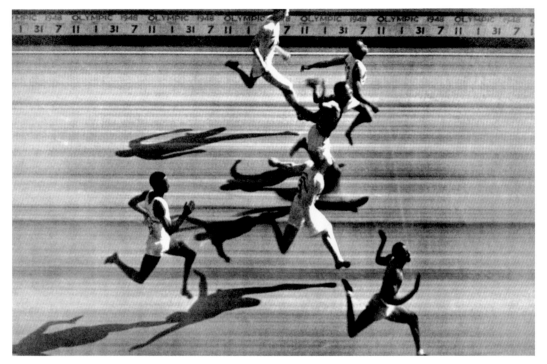

This dramatic photo finish of the men's 100m final was
the first time a photo finish camera had been used at the
Olympics. USA's Harrison Dillard (bottom) wins gold from
USA's Barney Ewell (second from top) and Panama's Lloyd
LaBeach (third from top).

31st July, 1948

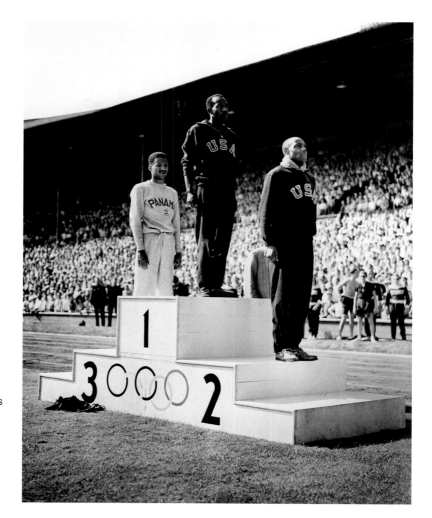

The medallists in the men's 100m stand to attention as the national anthem of the winner is played: (L–R) Panama's Lloyd LaBeach (bronze), USA's Harrison Dillard (gold) and USA's Barney Ewell (silver).
31st July, 1948

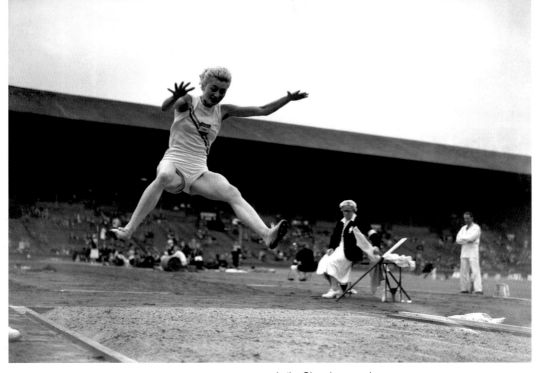

In the Olympic women's long jump, Hungary's Olga Gyarmati leaps to win gold with a jump of 5.695m.
4th August, 1948

The runners in the Olympic marathon make their way down Wembley Way away from the stadium.
6th August, 1948

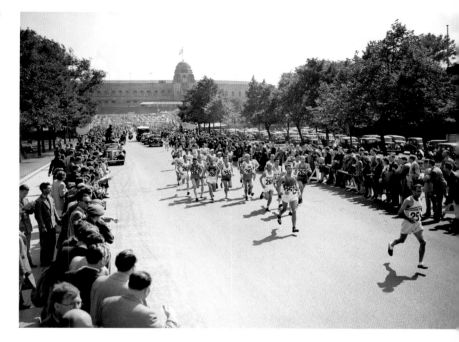

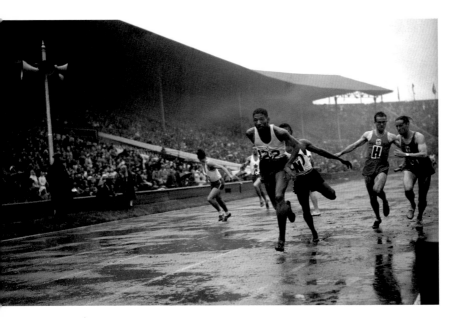

Jamaica's Arthur Wint takes over the baton to run the last leg in the Olympic men's 4 x 400m relay.
6th August, 1948

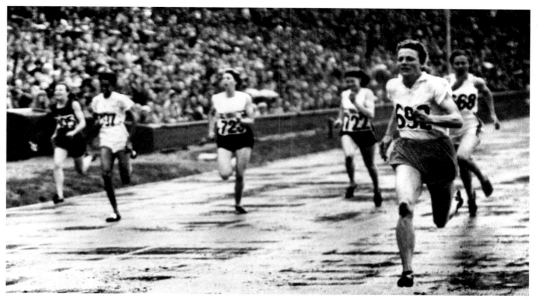

Holland's Fanny Blankers-Koen (R) sprints away to win gold from Great Britain's Audrey Williamson (723) and USA's Audrey Patterson (707) in the Olympic women's 200m final.
7th August, 1948

Argentina's Pascual Perez (R), who was shorn of his long hair by teammates when it was thought he was slightly over the weight limit (an unnecessary precaution as the scales were discovered to be slightly out), steps back after flooring South Africa's J. Williams in their third round bout. Perez went on to win the flyweight division Olympic gold medal.
10th August, 1948

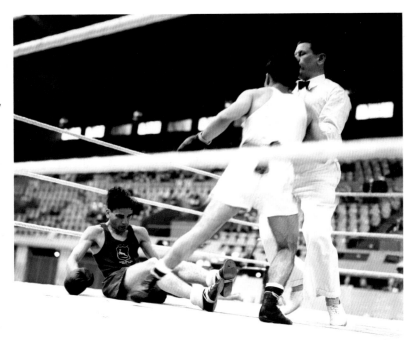

'Manny' Shinwell, War Secretary, sees off 1,500 officers and men of the 2nd Guards Brigade from Ocean Dock in Southampton, aboard the *Empire Trooper.* The soldiers are on their way to quell a State of Emergency in Malaysia (former British Malaya).

5th September, 1948

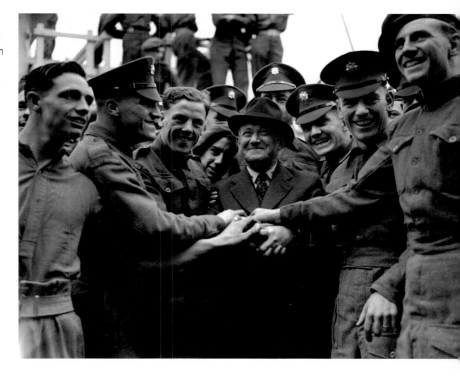

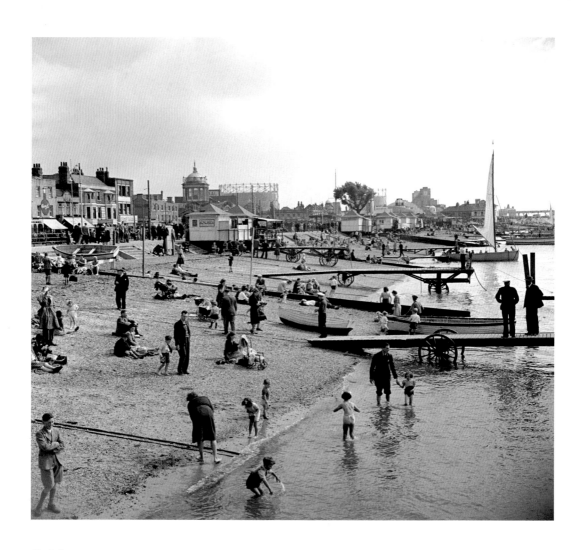

Aircraft flying over Nelson's Column in Trafalgar Square during the Battle of Britain fly-past, part of the annual celebration of the air victory achieved in 1940.

15th September, 1948

Facing page: A view of an archetypal British seaside resort, the beach at Southend-on-Sea, Essex.

6th September, 1948

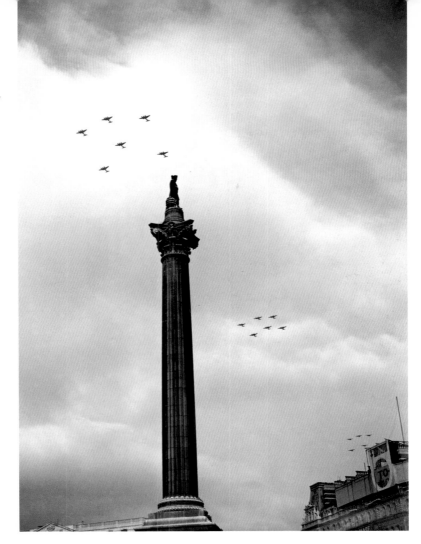

Two races were won by King George VI's horses at Ascot. Here is one of the two winners, Young Entry, Edgar Britt in the saddle, being led in after the filly's win.
8th October, 1948

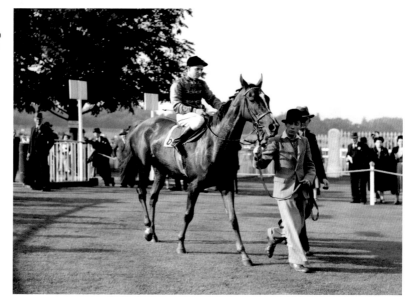

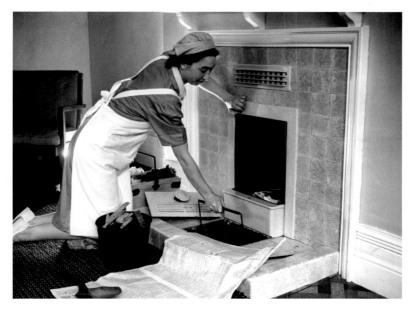

Student Gwen Sayers of Coventry learns the technique of cleaning and repairing a fireplace at the National Institute of Houseworkers' training centre at Croydon, Surrey.
12th October, 1948

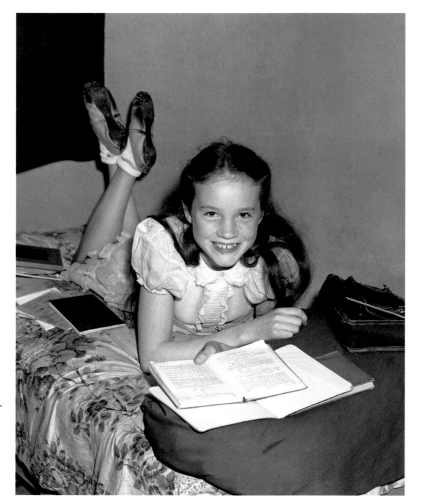

Julie Andrews, the 13-year-old coloratura soprano, of Walton-On-Thames, is the youngest star chosen for the Royal Command Variety Performance at the Palladium.
14th October, 1948

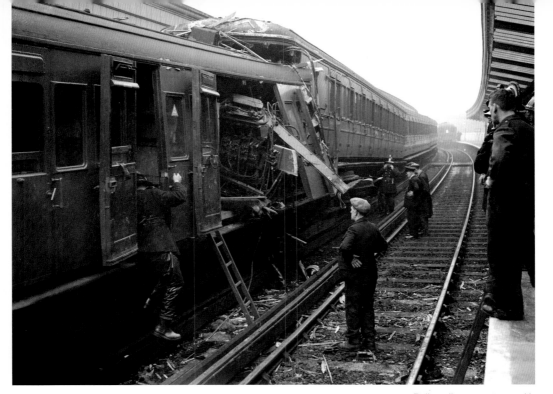

Railway lines are strewn with wreckage after a train from Charing Cross to Dartford ran into the back of a Cannon Street to Gravesend train, standing in Woolwich Arsenal Station, London. Two people were killed, and two were injured.
18th November, 1948

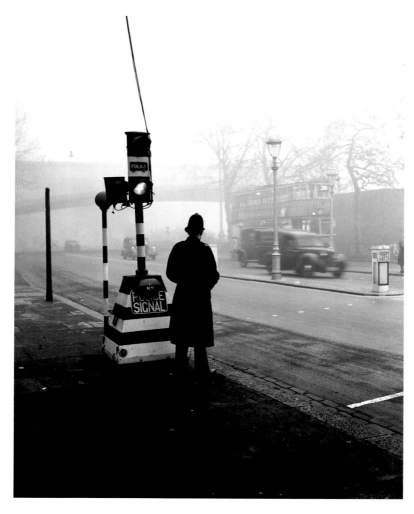

A policeman on the
Embankment, London
watches the traffic flowing
through foggy autumn
conditions with, at his side, a
police traffic signal.
27th November, 1948

The engine driver of the
Queen Mary boat train
receives last minute
instructions from the
supervisor at Waterloo
Station, before setting off
on his foggy journey to
Southampton.
30th November, 1948

Wearing a somewhat simplistic outfit, Father Christmas distributes early presents to children.
8th December, 1948

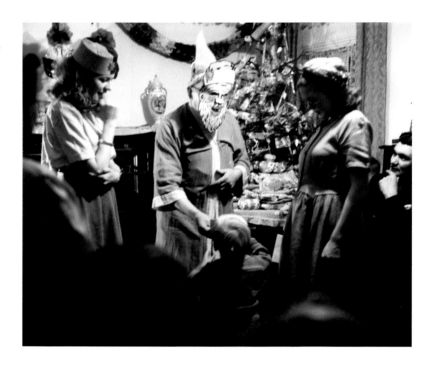

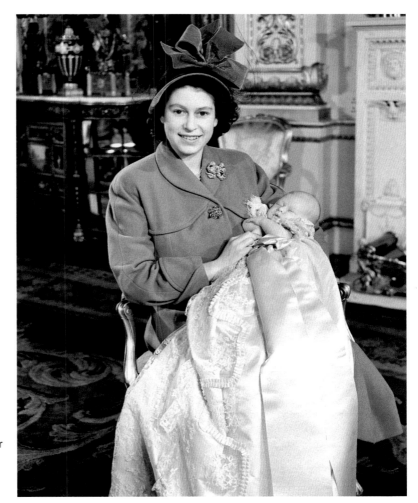

Princess Elizabeth holds her baby son, Prince Charles, after his christening in Buckingham Palace.
15th December, 1948

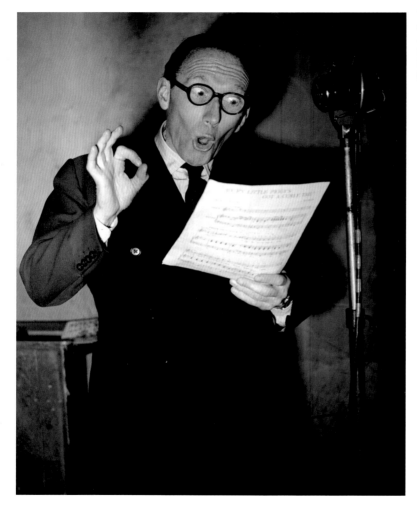

The popular radio and stage comedian Arthur Askey at the microphone at the EMI studios in Abbey Road, London.
24th January, 1949

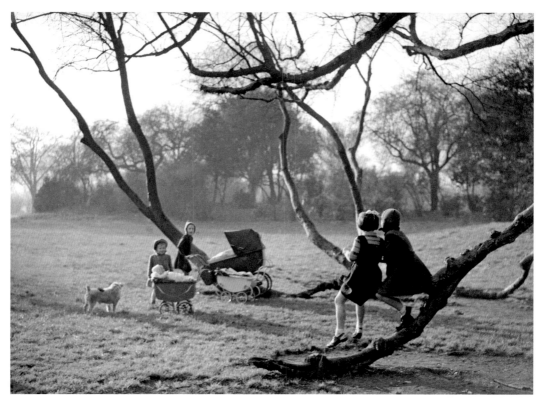

A group of girls playing
in Regent's Park, London
on an unseasonably mild
winter's day.
1st February, 1949

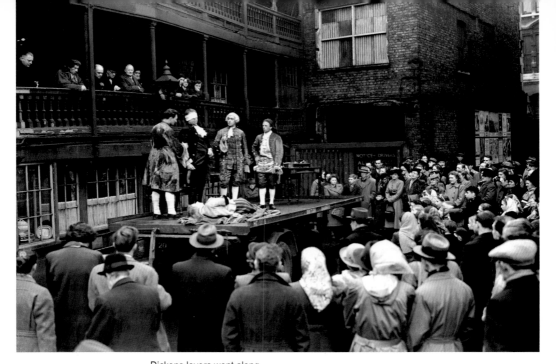

Dickens lovers went along
to The George Inn,
Southwark, to watch
scenes from *A Tale of Two
Cities* presented by the
Dickensian Tabard Players.
The occasion was the 137th
anniversary of Charles
Dickens' birth.
12th February, 1949

Shoppers at Selfridges store in London selecting from the underwear department, at the end of clothes rationing.
15th March, 1949

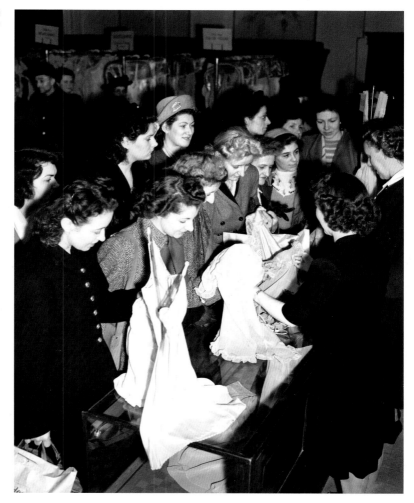

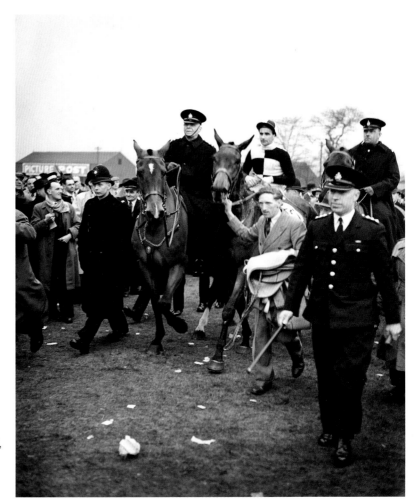

Russian Hero, with Leo McMorrow in the saddle, is led in after winning the Grand National. Forty-three horses began the race but the 66–1 outsider forged ahead, relegating Roimond and jockey Mr R. Francis to second place with Cromwell, ridden by Anthony Bingham 'Nitty' Mildmay, 2nd Baron Mildmay of Flete in third.
26th March, 1949

Ernest Bevin, Foreign
Secretary, signing the
North Atlantic Pact on
behalf of Britain, in the
auditorium of the United
States Department in
Washington. Looking on is
Sir Oliver Franks (L), British
Ambassador to the US.
4th April, 1949

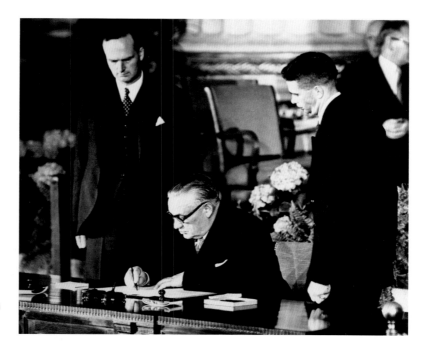

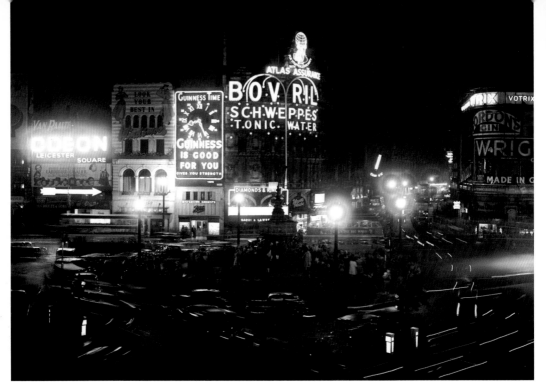

Electric signs light up
Piccadilly Circus, London for
the first time since the
Second World War.
4th April, 1949

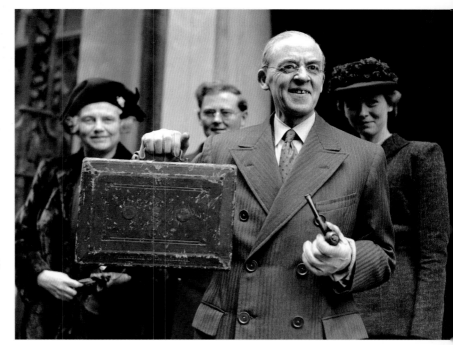

Sir Stafford Cripps, Chancellor of the Exchequer, waves the famous despatch case as he leaves 11 Downing Street for the House of Commons to present his budget.
6th April, 1949

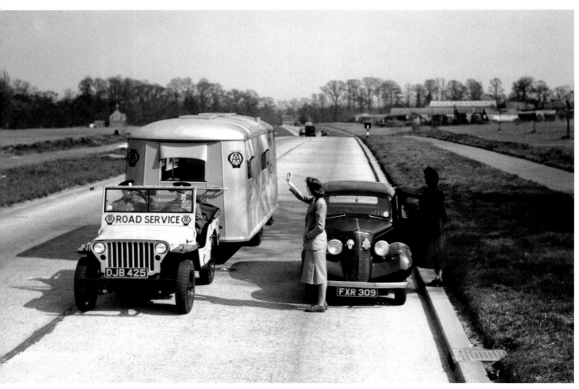

Motorists on a Surrey road hail an AA mobile office. The
Automobile Association, founded in 1905 to help motorists
avoid police speed traps, led the protest against petrol
rationing after the Second World War, which was repealed
in 1950. In 1949 it launched a night-time breakdown and
recovery service initially in London only before extending
it nationally.

6th April, 1949

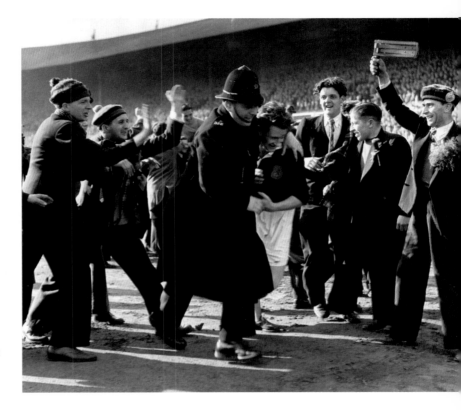

Scotland captain George Young is rushed off the pitch by a policeman after his team won 3–1 against England to take the British Home Championship at Wembley Stadium.
9th April, 1949

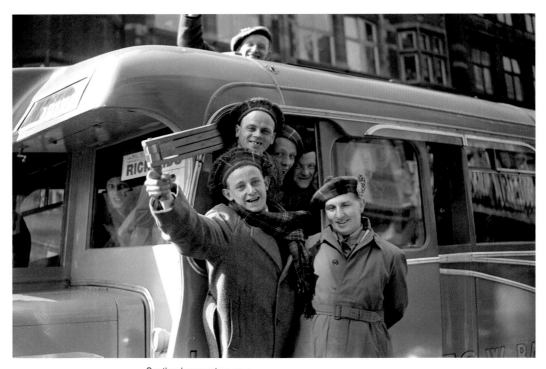

Scotland supporters on a
London bus celebrating with
rattles after their team's 3–1
victory over England in the
British Home Championship.
9th April, 1949

Much-loved American comedian Danny Kaye photographed in his London hotel with a roll of film draped round his neck. When he appeared at the London Palladium in 1948, he was said by the American press to have *"roused the Royal Family to shrieks of laughter and was the first of many performers who have turned English variety into an American preserve."* Kaye was invited to return to the Palladium in November of the same year and, although he was busy at work on *The Inspector General,* Warners stopped work on the film to allow their star to attend.
19th April, 1949

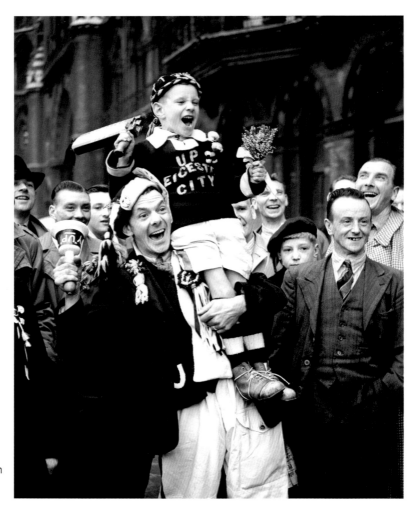

Leicester City fans in London
for the FA Cup final.
30th April, 1949

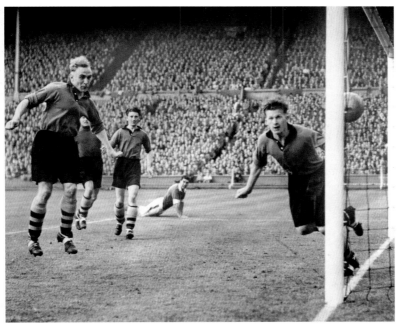

In the FA Cup final, Wolverhampton Wanderers' Billy Wright (L), Terry Springthorpe (second L) and goalkeeper Bert Williams (R) can't prevent the ball from going in the back of the net. Leicester City's Ken Chisholm (C) looks on.
30th April, 1949

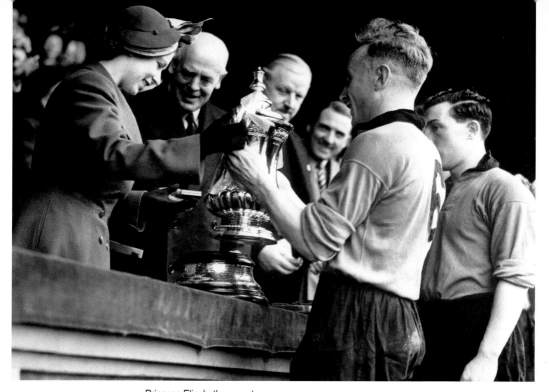

Princess Elizabeth presents
the FA Cup to Billy Wright,
captain of Wolverhampton
Wanderers, after they
defeated Leicester City 3–1 in
the final at Wembley Stadium.
30th April, 1949

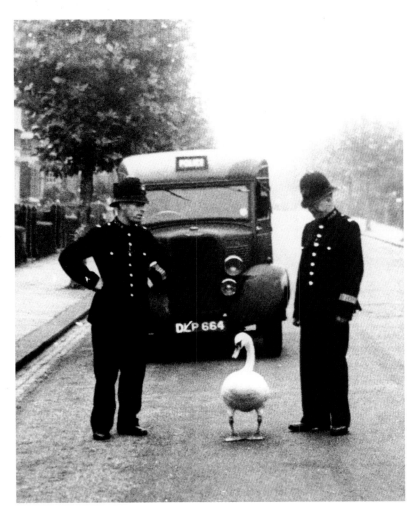

Two policemen decide what to do with a swan that will not move from the road.
1st May, 1949

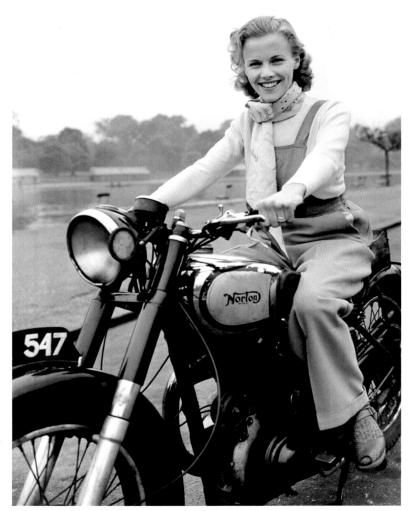

Actress Honor Blackman, aged 23, poses on a motorcycle in Hyde Park, London. At this time Guildhall School of Music and Drama tutored Blackman's film roles had been minor, but she would become widely known for the roles of Cathy Gale in *The Avengers* (1962–64) and as Bond girl Pussy Galore in *Goldfinger* (1964).

9th May, 1949

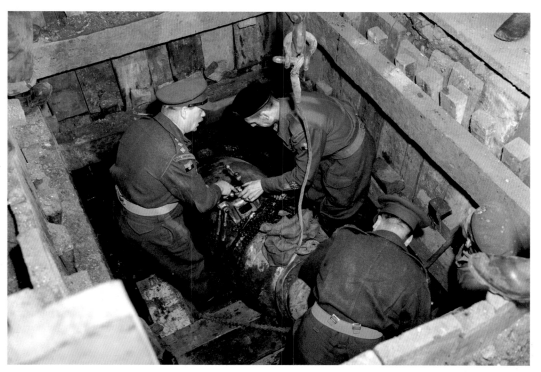

The Royal Engineers
defusing a 2,500 pound high
explosive bomb found in
Dagenham, Essex.
21st May, 1949

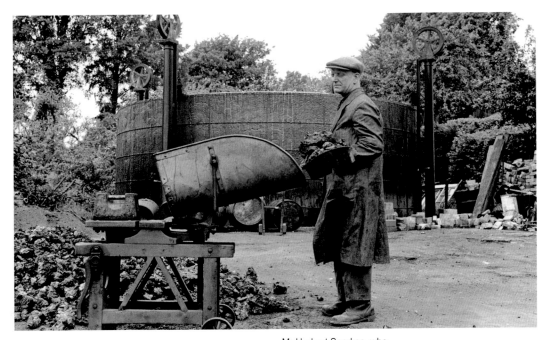

Mr Herbert Sparkes, who
is alone responsible for
servicing and running what
is claimed to be the smallest
gasworks in the British Isles.
25th May, 1949

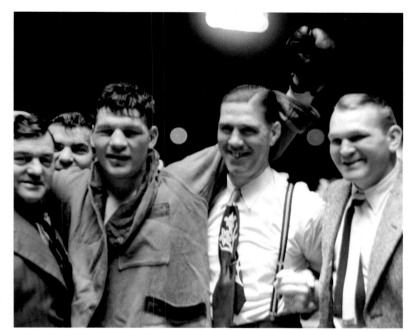

A victorious Bruce Woodcock (third R) is exultant after winning the vacant British and European and Empire heavyweight boxing titles by a KO against Freddie Mills in round 14.

2nd June, 1949

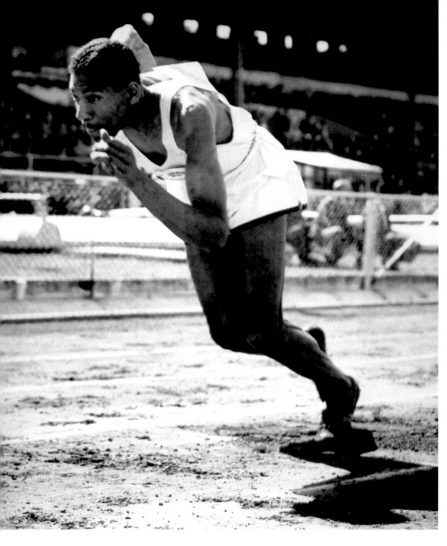

Arthur Wint, the West Indian runner, getting away to a good start for the 440 yards at the British Games at White City. He won the race and broke the British record.
6th June, 1949

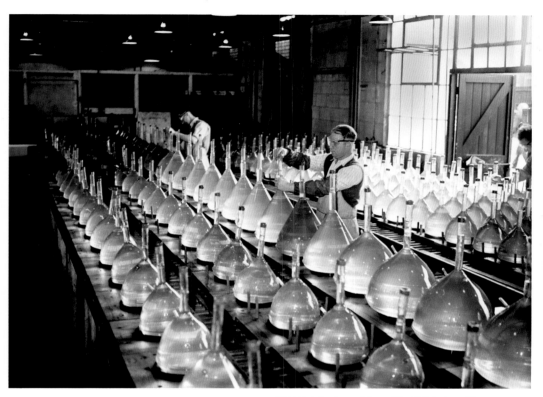

Making cathode ray tubes at the EMI factory. The CRT, a vacuum tube containing an electron gun and a fluorescent screen, was used to create images in the form of light emitted from the fluorescent screen – an essential component in the television, a form of entertainment that was rapidly growing in popularity.
8th June, 1949

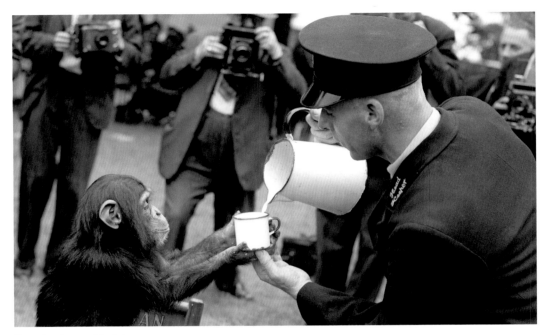

Susan has her cup filled at
the Chimpanzees' Tea Party
at London Zoo.
13th June, 1949

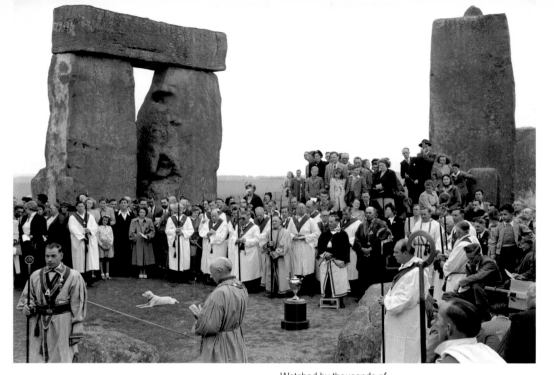

Watched by thousands of spectators, members of the Haemus Lodge (Brighton and Worthing District of Sussex) of the Ancient Order of Druids conduct their annual midsummer ceremony within the stone circle at Stonehenge, Salisbury Plain, Wiltshire.
20th June, 1949

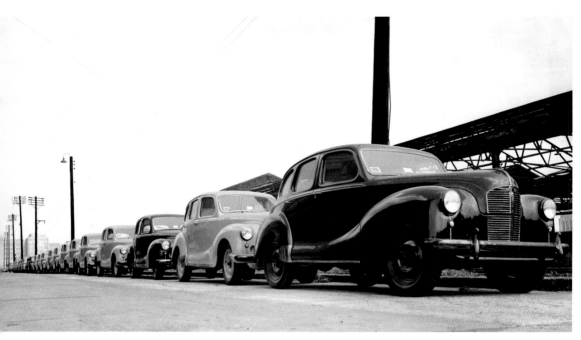

Cars waiting to be loaded during the London dock strike.
British dockers had struck in solidarity with members of the
Canadian Seamen's Union, who were striking over wage cuts.
Troops were moved into London docks to unload ships, but
drivers of haulage firms refused to carry the goods. The Labour
Government announced it would proclaim a State of Emergency,
which resulted in watermen, lightermen, tugmen and bargemen
joining in. By 20th July, over 15,000 men were on strike, only
returning to work on the 22nd when the CSU, having obtained
concessions, terminated the dispute.
15th July, 1949

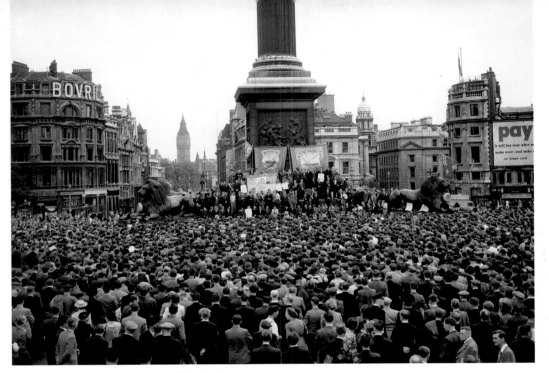

A crowd listening to
speakers in Trafalgar Square
during a mass meeting of
striking dockers.
17th July, 1949

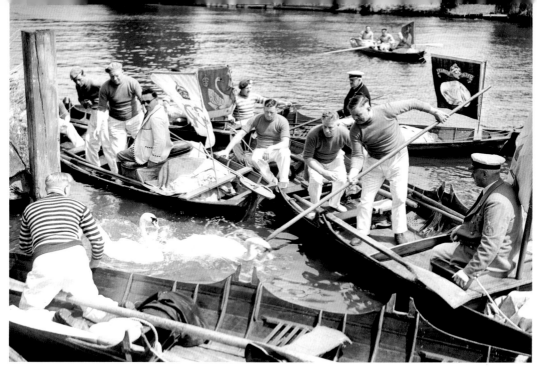

One of the crew pulls in a parent swan with a hook, during annual Swan Upping ceremony on the River Thames, in which mute swans are caught, marked and then released. Traditionally, the monarch of the United Kingdom retains right to ownership of unmarked mute swans in open water. The practice dates from the 12th century, when swans were a common food source for royalty. Today it serves as a swan census and a check on the health of swans.

20th July, 1949

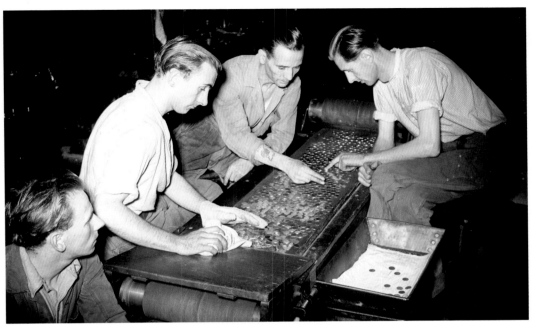

Sorting blanks for die
stamping of sovereigns at
the Royal Mint.
21st July, 1949

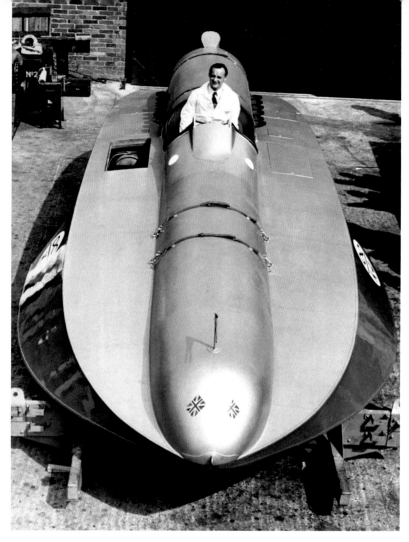

Donald Campbell sits in his father Malcolm's *Bluebird* hydroplane, the boat he will use for an attempt on the world water speed record.
22nd July, 1949

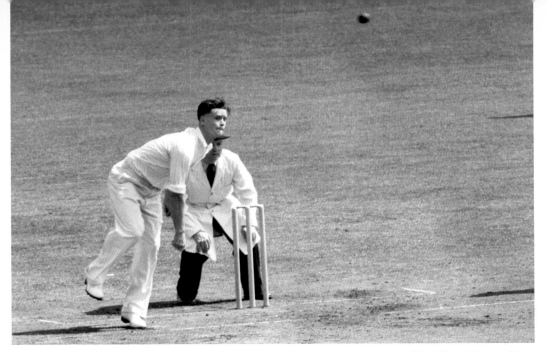

Brian Close, 18 years old, the youngest ever player to represent England in a Test match, bowling on his debut against New Zealand.
23rd July, 1949

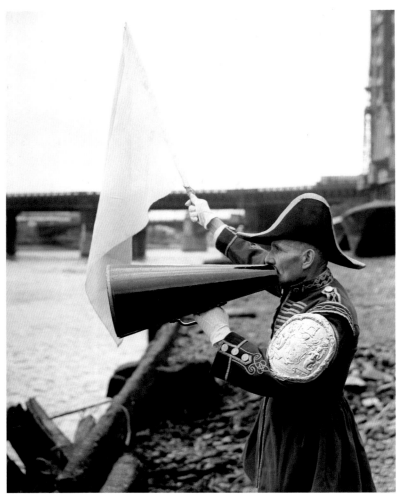

Wearing his ornate uniform as Bargemaster to the Fishmongers Company and assisted by a megaphone, Mr Harry Phelps starts the 235th race of the Thames Watermen for Doggett's Coat and Badge at London Bridge.
29th July, 1949

Facing page: A crowd gathers to read the notices posted on the doors of Wandsworth Prison, London following the execution of John George Haigh, 39, for the murder of Mrs Olivia Durand-Deacon, a 69-year-old Kensington widow. Haigh, known as the 'Acid Bath Murderer' was convicted of murdering six people. He dissolved their bodies in concentrated sulphuric acid before forging papers to sell their possessions and collect substantial sums of money.
10th August, 1949

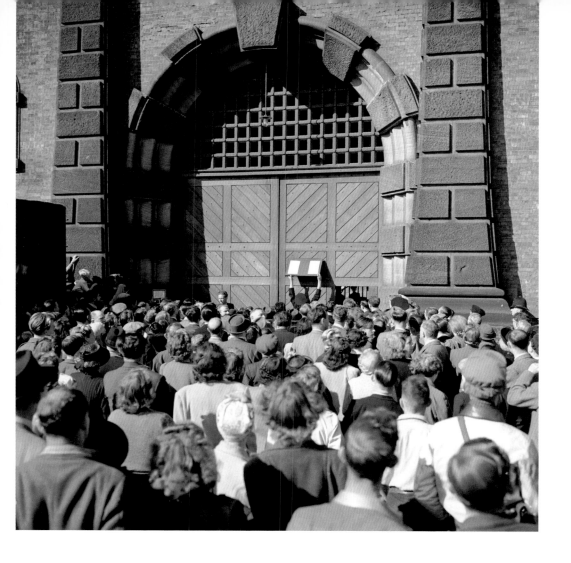

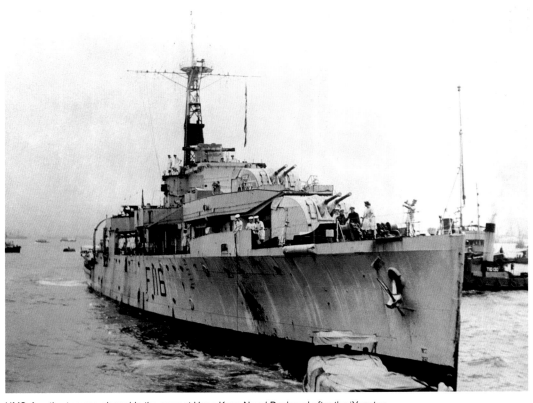

HMS *Amethyst* comes alongside the quay at Hong Kong Naval Dockyard after the 'Yangtze Incident'. On 20th April the frigate was heading from Shanghai to Nanjing to stand guard for the British Embassy during the Chinese Civil War, when she was fired on by Chinese Communists. Run aground, she was held under guard for ten weeks, but on 30th July slipped her chain and headed downriver on a 104-mile dash for freedom running the gauntlet of Communist guns on both banks. Arriving in Hong Kong on 11th August, she transmitted the signal: *"Have rejoined the fleet off Woosung...God save the King."*
10th August, 1949

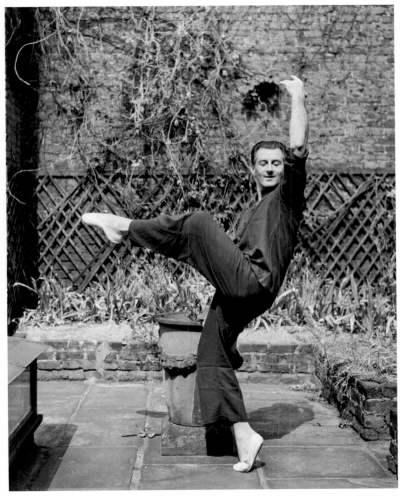

Ballet dancer Anton Dolin, flexing his muscles on the terrace of his London home after flying back from Cannes, where he had been beaten up and robbed at the hands of a notorious Riviera bandit who the French police had been hunting for two years. Dolin was able to identify him, leading to his arrest.

20th August, 1949

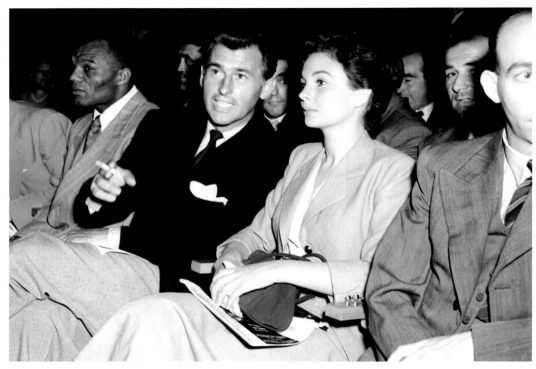

Film stars Stewart Granger
and Jean Simmons watching
the boxing at Harringay
Arena, London.
6th September, 1949

Men of the Thames Police rehearsing for the pageant they are presenting to commemorate the 150th anniversary of their force.
8th September, 1949

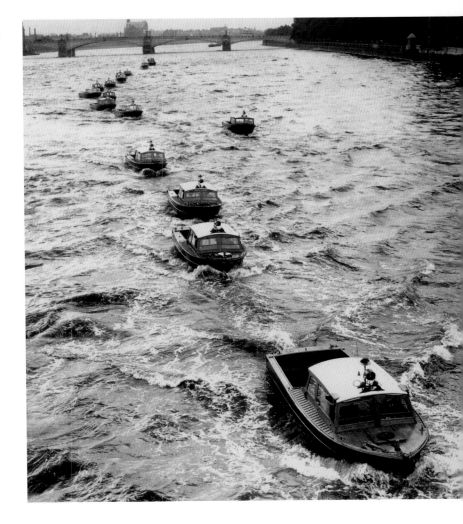

Foreign Minister Ernest Bevin arrives back at Southampton after talks in Washington, USA on Operation Valuable: British and US naval officials were concerned that the USSR was building a submarine base at the Karaburun Peninsula near the port of Vlorë, Albania. On 6th September, when NATO met for the first time in Washington, Bevin proposed that *"a counter-revolution"* be launched in Albania. Bevin waves his hat in cheerful response to dock workers' cries of *"Good old Ernie"*.

12th October, 1949

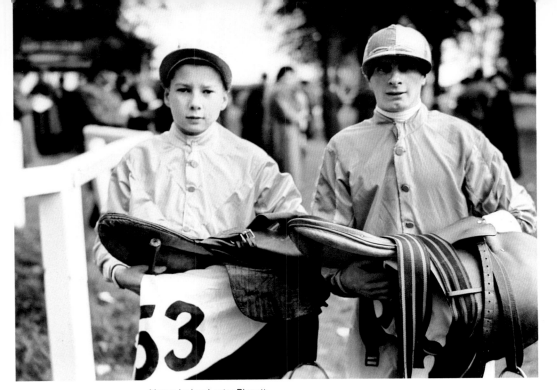

Young jockey Lester Piggott (L), with K Southwell, began racing horses from his father's stable when he was just 10 years old, winning his first race at Haydock Park in 1948, aged 12, on The Chase. With 4,493 career wins he became one of the most well-known English flat racing jockeys of all time.
27th October, 1949

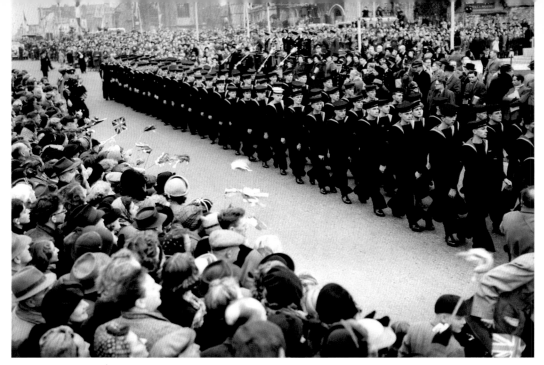

One of the greatest
welcomes ever accorded a
ship's company was given
to the 150 sailors from the
frigate HMS *Amethyst* when
she docked at Devonport,
Plymouth, at the end of her
10,000 mile voyage after
the Yangtze Incident. Here
the ship's company march
through the crowded streets
of the city.
1st November, 1949

Comedian Michael Bentine, 29, rehearsing his act two days before his appearance at the Royal Command Performance, to be held at the London Coliseum.
5th November, 1949

Comedian Bob Monkhouse
and his bride Elizabeth
Thompson at their wedding
reception at Caxton Hall,
London, while actor Harold
Berens takes a surreptitious
bite of their cake as they
attempt to cut it.
5th November, 1949

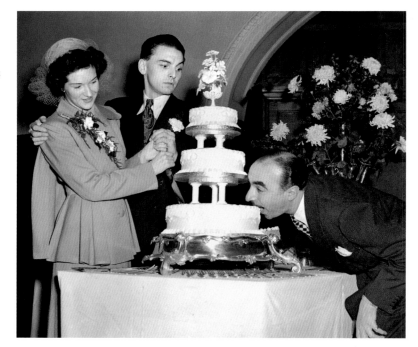

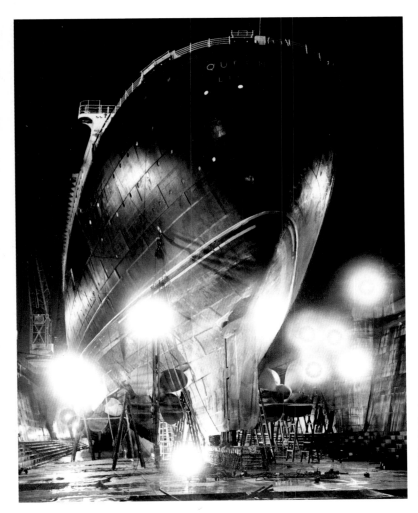

Towering above the King George V dry dock at Southampton is the gigantic hull of the Cunard-White Star liner *Queen Mary* as she undergoes a six week overhaul and renovation.
10th November, 1949

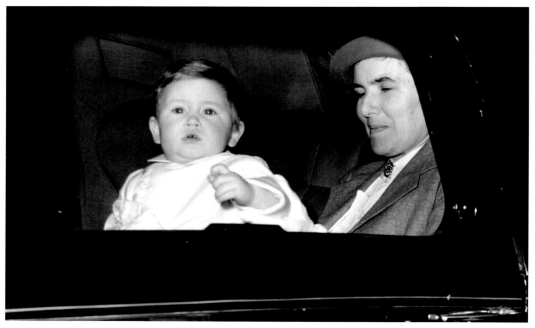

The Prince of Wales on his
first birthday, being driven
from Marlborough House,
London after visiting his great-
grandmother Queen Mary.
14th November, 1949

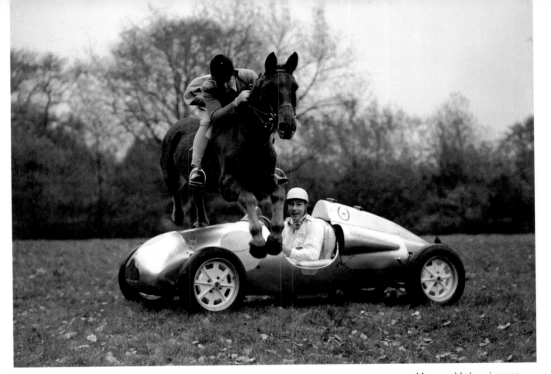

14-year-old show jumper Pat Moss jumps her pony over her 20-year-old brother Stirling Moss' racing car at their father's farm at Bray, Berkshire.
19th November, 1949

Actor and comedian Arthur
English plays pepper pot
draughts with Windmill Girl
Madeleine Hearne (R),
watched by her colleagues
Irene King and Beryl
Catlin, in the canteen of the
Windmill Theatre, London.
27th November, 1949

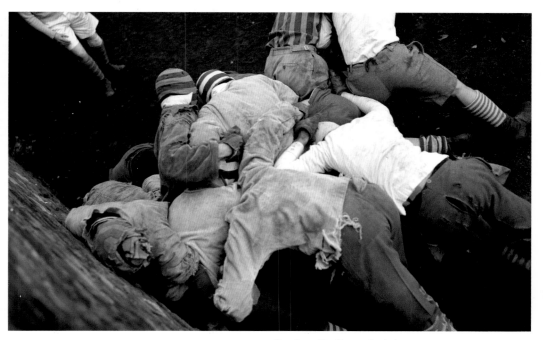

Heads and bodies are buried in the scrum of the Eton Wall Game, a game similar to football and Rugby Union, which originated from and is still played at Eton College, near Windsor. It is played on a strip of ground 5 metres wide and 110 metres long next to a slightly curved brick wall that was erected in 1717.
30th November, 1949

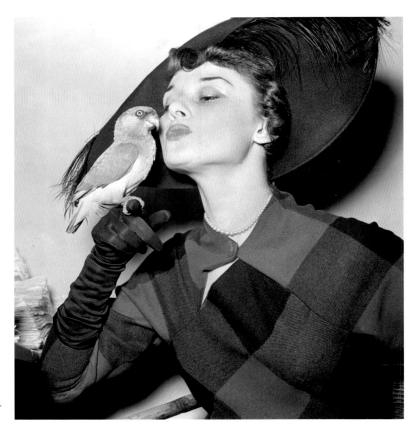

Audrey Hepburn, principle
dancer in the London
musical *Sauce Tartare*,
makes friends with a macaw.
1st December, 1949

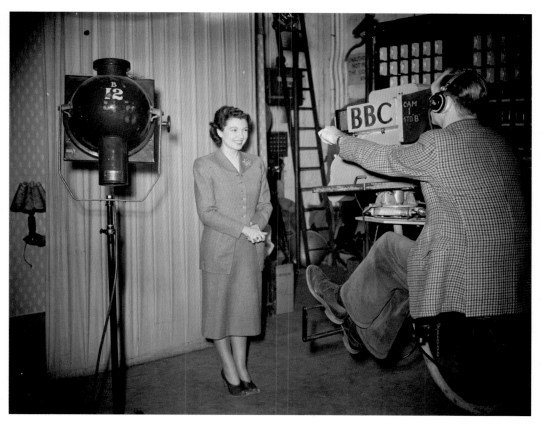

Actress and television continuity announcer Sylvia Peters
stands before a BBC television camera. After answering a
newspaper advertisement in June 1947, she was chosen
from hundreds of applicants and remained in the job until her
retirement in 1958.

8th December, 1949

The Publishers gratefully acknowledge Press Association Images, from whose extensive archives the photographs in this book have been selected. Personal copies of the photographs in this book, and many others, may be ordered online at www.prints.paphotos.com

AMMONITE
PRESS

**PRESS
ASSOCIATION**
Images